...purchase of Bruno Chemiker Leo Klagsbrunn, ...asse which I took over on 17/3 1938." ... the comments about "the spread... ...that gave us a bad name with her ...with the District Party leadership." ...losses by the competition which ...since the purchase had ...remained, approval was ...however, did nothing to ...WNHAL OQ of ...Economic Affairs, ...is Floridsdorf- ...Transfer Office,

THREE TEARLESS HISTORIES

ERICH HACKL

Three Tearless
Histories

Translated by Mike Mitchell

DOPPELHOUSE PRESS • LOS ANGELES

Three Tearless Histories

By ERICH HACKL

Translated by MIKE MITCHELL

Copyright © 2017 by DoppelHouse Press

Drei tränenlose Geschichten

Copyright © 2014 by Diogenes Verlag AG Zürich

ISBN 978-0-9970034-3-7

DESIGNED BY CURT CARPENTER

Partial support for this translation thanks to the Bundeskanzleramt Österreich.

Publisher's Cataloging-in-Publication data
NAMES: Hackl, Erich, author. | Mitchell, Mike, translator.
TITLE: Three tearless histories /by Erich Hackl ; translated by Mike Mitchell.
DESCRIPTION: Los Angeles, CA: Doppelhouse Press, 2017.
IDENTIFIERS: ISBN 978-0-9970034-3-7 | 97809970034-5-1 (ebook)
LCCN 2016958417
SUBJECTS: LCSH Austria. | Klagsbrunn, Kurt, 1918-2005. | Brasse, Wilhelm, 1917-2012. | Tschofenig, Gisela. | Tschofenig, Pepe. | Photographers--Austria--History. | Photographers--Poland--History. | Expatriate artists. Holocaust, Jewish (1939-1945)--Austria. | Auschwitz (Concentration camp). | Holocaust, Jewish (1939-1945)--Poland. | Austria--Emigration and immigration. | Brazil--Social life and customs. | BISAC PHOTOGRAPHY / Individual Photographers / Essays | PHOTOGRAPHY / History
CLASSIFICATION: LCC JV8015 .H33 2017 | DDC 940.53/086--dc23

DoppelHouse Press
LOS ANGELES, CALIFORNIA

CONTENTS

The Klagsbrunn Family

A STORY COMING TO LIGHT

1

THERE'S NO FAMILY TREE, so it's imperative we stick to the photo in which they're looking out at us from a whole century ago. Ignaz Klagsbrunn, the head of the family, amiable, relaxed or even with an ironic smile beneath his well-groomed mustache. With his right hand he's holding his granddaughter Flora by the arm, his left is placed on the ornate round table on which his wife Johanna is also leaning, with Rosi, their second grand-daughter, in her lap. Johanna Klagsbrunn, née Thieberg, has thick, dark hair, just about kept in place by a center

parting, while her husband's fair hair seems to be thin and already receding at the temples. Two people of surprisingly contemporary appearance, close to ours, who look contented but neither serene nor split into an authoritarian brow and a forbearing heart. And still astonishingly young. In the prime of life.

All eleven children are sitting or standing around the couple in a suggestion of a semicircle. At the front, on crudely made garden chairs, the two eldest, their daughters Lola and Bertha. At an angle behind them, the spitting image of each other in stature, hairstyle, luxuriant whiskers, their husbands Karl Goldstein and Benno Ostiller. Doctors of medicine both of them, moreover neighbors in the same house, 51 Leopoldsgasse, where they pursue their profession. It is striking how far Bertha Ostiller is leaning back, has put her forearms behind her back, her unusual posture and the suggestion of a bulge under her loose dress, that comes down to the ground, make us think she might be pregnant.

It isn't difficult to distinguish between the Klagsbrunn sons and the sons-in-law (the third, Sida's husband Johann Frey, has a pince-nez and a Vandyke beard), for some of the former, like the daughters, clearly take after

their mother: their dark eyes, their melancholy look, their unmanageable mop of hair. Only the two eldest sons, Josef and Hugo, resemble their father, though less in their appearance than in the indulgent interest they take in the photographer or his plate camera. In fact no one shows a lack of attention. Perhaps the youngest daughter, Cilla, is looking a bit sullen. Or impatient because she has to keep still too long for her taste.

Not one of them is smiling, neither Bruno who, forty years later, will die together with his wife Grete in a subcamp of Jasenovac Concentration Camp, nor Samek, of whom we read that he has been missing since 1938, nor Molo (i.e. Maximilian) who will have a dental practice in the center of Vienna, then flee to Shanghai with his wife Frieda and finally die, destitute, in San Francisco, nor Noli, (Dietrich Arnold) who, five decades later and with a persistence matched only by his lack of success, will demand the restitution of or compensation for the equipment and other furnishings which the two dealers, Josef Prossnitz and Theodor Partik, removed from his own dental surgery in the Mariahilf district of Vienna in September 1942. Stole, to be more precise, and since it is accepted that they were acting 'on the instructions of the

former Property Transfer Office' the Federal Ministry of Finance sees no reason to grant his request for restitution.

Leo, the second youngest in the family, isn't smiling either. He's standing in the back row, in front of the terrace door with the windows that reflect the light, and wearing a high wing collar going around his neck like a ruff. At the time the photo was taken he's sixteen years old.

2

I FIRST MET LEO'S GRANDSON two and a half years ago in Rio de Janeiro. The Universidade Federal Fluminese, the campus of which is in Niterói, on the other side of the bay, had invited me to give a number of lectures and after the first few days in Rio I was somewhat surprised that the inhabitants did not at all conform to the image that is generally ascribed to them: I found them neither particularly cheerful nor loquacious or bubbling over with vivacity. Until I got to know Victor Hugo Klagsbrunn that is. He was warm-hearted in a way that was almost incidental, assured, imaginative and blithely unconcerned about time. But—with one exception: for my final lecture we arrived in Niterói an hour and a

half late—things always worked out at the last minute. An authentic *carioca*, then, surrounded by unauthentic, depressed and harassed seeming citizens of Rio, even though, or because, Victor's father came from Vienna, his mother from Berlin and he'd spent almost sixteen years in exile. He invited me to his home, a spacious, luxuriously furnished apartment in Copacabana, where I met his wife, Marta, who had been together with him in exile, and a barking white ball of wool that answered to the name of Tuca.

There, in the Rua Ministro Viveiros de Castro, Victor keeps something which I think gives him the most pleasure of all his family heirlooms: a poster of the Floridsdorfer Athletiksport-Club announcing two matches in the Austrian soccer championship being played at the Hohe Warte stadium on the same day, Sunday 11 September: FAC against Wacker and Vienna against WAC. As Victor discovered, the poster is from 1932 and has, among many others, adverts for his grandfather's coal business, Karl Jizda's sports equipment shop and the Sinai Clothing Store. Karl Jizda was a legendary center-forward for the FAC, Leo Klagsbrunn its president and the Sinai Clothing Store was on the first floor of Am Spitz 2 where the

club also had its premises. We will come across that store again under the misleading and disrespectful designation of furniture shack. And the match didn't take place on the Sunday but on the Saturday, as Victor's grandfather wrote on the poster in blue pencil, and FAC beat Wacker Wien 3-2, with goals from Pepi Stroh (2) and Gustl Jordan.

There was only a little Victor could tell me about the history of his forebears, for the early death of his father and his own circumstances had prevented him from familiarizing himself with them. On the other hand he did present me with a pile of documents. Most came from the estate of his Uncle Kurt, others he'd had someone dig out of the Austrian State Archives for him. And he told me his own story, and Marta hers, the story of their life together. A story of persecution, worse than that of his parents and grandparents. I will relate both of them, the way I heard and remembered them, the way Victor and I investigated them in Vienna two months later, and the way we have reconstructed them since then in a question-and-answer carousel between here and there: the basic data, rather sparse, not very vivid, without feelings, which our imagination has to supply.

3

A S WAS COMMON in those days, the family photo was used as a postcard. Since there was only enough room on the back for the name and address of the person to whom it was being sent, Ignaz Klagsbrunn had written his news over, beside and under the picture: "My dear children," and along the top the date and time of the card: "Floridsdorf, 22/9/1904, 10 p.m. weather fine."

The photo must have been taken before that, however, in March or even the end of February, for the trees beside and behind them, and reflected in the windows behind Leo's head, are bare. And the daughters, apart from Bertha, have long fur stoles over their light-colored clothes. The men dark coats. Jackets under their coats.

Stiff collars with ties or bows. All of them people with assured taste who can afford well-made, good-quality clothes. The little villa, in front of which they're posing, wouldn't stand out in a middle-class district but there, in Pilzgasse, right behind Floridsdorf freight depot where there are only low houses plastered with clay, a soap factory and the Shell oil refinery, it looks if it's been conjured up out of thin air. Klagsbrunn Villa.

WE KNOW very little about Ignaz and Johanna Klagsbrunn. That they—to go by their looks and the date of birth of their eldest daughter—were born in the middle of the nineteenth century and come from Wadowice, a Polish county town which lies at the foot of the Beskids, some thirty miles to the south-west of Kraków, and which in those days belonged to the Austrian crownland of Galicia but is today best known as the birthplace of Karol Wojtyla, later Pope John Paul II.

Their children were also born in Wadowice, apart from Bruno who was born in Vienna in July 1892, where the family had settled two or three years previously. His parents are listed in Lehmann's Vienna Directory for 1891, Ignaz running a business selling laundry

materials and specializing in ironing whites with glaze starch, Johanna an innkeeper, both at 5 Mühlfeldgasse. After 1895 Johanna's name is deleted, suggesting that by then her husband is providing for the family on his own—in the Directory he is listed in turn as publisher of a handbook on laundry and ironing whites with glaze starch, head of a private trade school, inventor of a new method of ironing with glaze starch, producer of chemical products and dealer in flatirons and laundry equipment. Puzzling over and discovering things seems to be in the genes of the male Klagsbrunns; later on Noli will have a wax syringe for dental use patented and his elder brother Josef the 'Microna' universal mill. In or around 1899 the family moves to Floridsdorf, where Ignaz has bought the villa in Pilzgasse. A delivery note for 'Ignaz Klaksbrunn. Chemical Products Factory' of June 1909 has been preserved; it is for a ¼ case of 'Heliosin' glaze for fine linen.

FLORIDSDORF is on the left bank of the Danube, on the other side from the city of Vienna. Shipping, a lot of industry, ambitious tradesmen, an influx of people from Moravia and other outlying parts of the Monarchy look-

ing for work. Poverty as well, and not only just below the breadline. In the year the photograph was taken the place had around fifty-five thousand inhabitants and was to be incorporated into the Austrian capital as the 21st district, by the law of November 12, 1904. That same year also saw the founding of the FAC, which was to become so important for Leo. We don't know how he and his brothers got through the First World War; I suspect that, given their training as chemists and doctors, most of them will have seen service in clinics, field hospitals and laboratories.

The city of Vienna takes steps to combat the lack of affordable—and hygienic—accommodation with an ambitious program of social housing, in the context of which two large complexes are constructed between 1924 and 1932 that are to become the symbol of the Floridsdorf workers' movement: the Schlinger-Hof in Brunner Strasse and the FAC building in Freytaggasse, right next to the football pitch. During the uprising against the Dollfuss dictatorship in February 1934 both apartment complexes are fiercely fought over. Members of the Social-Democratic Schutzbund[1] and para-military

1. Republikanischer Schutzbund (Republican Protection Association): a paramilitary organization of the Social-Democratic Workers' Party.

exercise groups barricade themselves in there until, after a day and a night of being bombarded with grenades and mortars from the police and the army, they are forced to abandon them. Outside the Schlinger-Hof and in the police station in Hermann-Bahr-Gasse both police and members of the right-wing Heimwehr[2] shoot workers that have been arrested and disarmed. On February 14 Georg Weissel, a leader of the Schutzbund and captain in the fire service, is condemned to death by a summary court for 'refusal to obey orders and rebellion' and hanged a few hours later. In all seventy-one people die in Floridsdorf during the fighting. Nothing on the photo and hardly anything of what we know about the people in it points to this event. From what we have heard there is no shooting in Pilzgasse, and at that time the inhabitants of the villa are on a skiing holiday in Salzburg or on the Hochwechsel.

2. The Austrian Heimwehr (Home Defence Force) consisted of various local armed groups set up in the immediate aftermath of the First World War to defend Austria's frontiers and maintain order; they were extremely right wing and played an increasing role in politics, especially in suppressing the Socialists in 1934, the year after Dollfuss had suspended parliament and established an authoritarian regime.

4

THE PILZGASSE is the title of the memories Grete Gabmeier-Grach wrote down ten or more years ago for her grandchildren. A thin volume with a few photos that Frau Gabmeier gave to me and Victor to read when we visited her in December 2011. On our way there we passed an overgrown plot of land on which Villa Klagsbrunn, badly damaged by a bomb that hit it on March 12, 1945, had stood until the late fifties then had to make way for a modest summer house, until that was also torn down or simply allowed to fall into ruin.

Grete Gabmeier was born in 1927 and is the last person we could find in Vienna who still remembers the Klagsbrunn family—Leo and his wife and children, not

his parents, who were already dead by the time Grete, holding her mother's or her aunt's hand, looked around the villa for the first time. Right behind the front door was the larder with an ice-box full of blocks of ice, then a windowless corridor with, on the one side the kitchen, very narrow because a bathroom had been built in, and the dining room, on the other the office and the so-called middle room, from which you could go out onto the veranda, which didn't exist in 1904. On the second floor were the balcony room and two little attic rooms—the bedrooms for the family of four.

From the entries in Lehmann's Directory we know that after the First World War Leo took over the premises of his father's firm. But before that, after his training as a chemist, he ran a wholesale business for household goods and was a partner in the Buche Charcoal Trading Corporation. Initially his new firm, Leopold Klagsbrunn Chemist, also sold chemical products, but then he restricted himself to dealing in charcoal, coal and coke. He had several employees, eventually six, "all of them Aryan," as he was to be compelled to declare.

Leo is a striking figure in Floridsdorf, and not just because of his height, he's almost 6' 6" tall, but athletic as

well, affable and charming; at the Gänsehäufel lido on the Danube the heads of the young women turn when he takes a run-up on the wooden planks and does a racing dive into the water. To their disappointment, in October 1911 he marries Friederike 'Fritzi' Kohn from the Leopoldstadt district who's one year older and two heads shorter than him. Their first child, Karl Peter, is born on May 24, 1913, their second, Kurt Paul, on May 6, 1918. (It's a family tradition to give their sons two first names, either because the parents can never agree or because they want to let their children have the opportunity of deciding for themselves whether to take the one or the other; Karl Peter will use his second name.) In December 1926 the police authorities in Vienna grant Leo Klagsbrunn "permission to drive motor vehicles with an internal combustion engine unaccompanied;" in 1930 the Vienna Football Association issues an identity card for him showing that he is the Deputy Chairman of the First League, the top Austrian division. The photos on the card and driver's license show a slim young man with thick hair combed back and a carefully trimmed walrus mustache. He still has the melancholy, wistful look of his mother, who died in June 1914, ten years before her husband.

5

IN JANUARY 1920 Maria Pfeiffer, also known as Mitzi and sixteen at the time, starts work in Leopold Klags-brunn's firm as a clerk, a position she had had from May 1918 to February 1919 with C. Hauptmann's Widow & Sons (Roofing Felt and Tar Production). According to her niece Grete, the Klagsbrunns treated her like a daughter. In return, her employer certifies that she is hard-working, capable of working independently and absolutely trustworthy.

Their close relationship with Maria Pfeiffer also includes her family, Grete's mother Leopoldine and her brothers Rudolf and Josef. Rudolf Pfeiffer occasionally helps out in the firm as a driver. Actually he's a varnisher by trade, Josef trained as a saddler. They probably kept

being made redundant or were out of work for longish periods during the world economic crisis. In a photo from the early thirties the two of them, in baggy trousers and large peaked caps, are standing in front of the fence of the Klagsbrunn's villa, behind them the house with the wooden gables and the carved balcony rail on which Mitzi and Fritzi are leaning. You can't tell from their posture which is the employer and which the employee.

Maria Pfeiffer comes from a working-class family, her brothers are members of the Social Democratic Workers' Party and, in addition, Josef is a section leader in the Republikanischer Schutzbund. Both take part in the February uprising and after the defeat try to escape to Czechoslovakia. While Rudolf is arrested on the border and jailed for a few months, Josef manages to get to Brno. From there he carries on to the Soviet Union, where he joins the Communist Party. In 1936 he gets his wife and children to come and join him in Moscow then, in the same year, volunteers for the Spanish Civil War. He fights in the XIII, then in the XI International Brigade, ending up as a lieutenant of the Republican Peoples' Army. On an undated photo that was taken outdoors, in or near Almería, he is sitting in a basket chair in front of

huts, trucks and a bare, steeply rising slope, a beret on his head, his left arm in a sling and resting his bandaged left foot on a chair. After the defeat of the Republic he is interned in the Saint-Cyrpien Camp in France but is already back in the Soviet Union by the middle of April 1939. One month before that Leo Klagsbrunn and his family arrived in Brazil.

6

THERE OUGHT TO BE MORE that could be found out about about Peter and Kurt's years in Vienna than Grete Gabmeier's sketchy memories of Kurt's graduation celebration with his classmates in a beer-garden next to the Mautner mansion in Prager Strasse, to which her family was also invited. When Grete was born, Kurt was nine years old and, wondering what a new-born baby looked like, had accompanied his mother when she went to see the mother and child in hospital. He was, so the exceptionally pretty Grete was told, horrified at the sight of her. Such an ugly child, he is said to have cried out. She remembers the two of them—both Peter and Kurt—as rather quiet boys. But they will have had many friends,

both in the district and at the University where, at an interval of five years, they studied medicine. That at least is what is suggested by letters from Kurt's fellow student, Eva Rhoden, who also came from Floridsdorf. She managed to escape from Vienna, four months after the Klagsbrunn family left, with the help of the Gildemeester Organization, a fund to help non-religious Jews who wanted to emigrate that was controlled by the Gestapo and used to rob them of their assets.

Did Peter and Kurt have steady girlfriends in Vienna? We can probably assume that Peter did; in 1938 he was in his mid-twenties and sociable like his father. In the synagogue, so Victor was later told, by a family acquaintance in Berlin, he always stood right at the back and cracked jokes. Kurt is said to have enjoyed taking photographs even while he was still in Vienna. At that time there was as yet no suggestion that his hobby was to become both his vocation and his occupation.

7

ON MARCH 12, 1938, German troops invaded Austria. On that very same day officers Bricka and Denstedt, from Floridsdorf District Police Station, carried out a search of Leopold Klagsbrunn's house and the garage of his coal depot. According to the report, the following objects were found: "1 Nash (6 cylinder) 55 horse power, license number A 5068 less good repair necessary, 1 license plate, 1 registration certificate." Rudolf Pfeiffer is named as witness to the search. It's possible his sister hastily called him over so that the visit of the policemen wouldn't turn into a humiliation of her employer. It's also possible that the two officers feel ashamed anyway at having to inconvenience Klagsbrunn, who is well known

to them, with a search of his house; that they apologize for having to trouble him and quickly take their leave. Or, on the contrary, that they want to make the most of their sudden power.

For Leopold Klagsbrunn the political upheaval is not unexpected. For some time he's been thinking about emigration plans. Perhaps he's hesitated until now because of his sons; Peter hasn't long to go to his doctorate, Kurt has just started his fourth semester. Two countries are under consideration for refuge: the USA and Brazil. The widow and son of Leo's brother Hugo, who died in 1928, are living in Connecticut or New York, his brother-in-law Albert Kohn in Rio de Janeiro. Albert is also a chemist and works for *Brasil Perfumista*, the magazine of the Brazilian perfume industry. Fritzi's parents happen to be visiting him at that very moment. They're going to stay there. But that isn't the reason why Leo and Fritzi decide on Brazil: it's the only country that will also grant their sons visas. The United States would have given the parents alone an entry permit.

Allegedly they talked to Maria Pfeiffer before this, without obligation, about whether she could see herself taking over the business and the house in the near future.

She is perfectly familiar with the work, gets on well with both customers and suppliers but can also, where necessary, be forceful and persistent. Her savings, if she has any at all, will be nowhere near enough for anything like a reasonable purchase price for the house, depot, stock and the two vehicles (as well as the car there is a truck), but she has a relationship with Arthur Egger, an engineer with the Austrian Federal Railways (from now on the German Reich Railways), who would perhaps be able to get his hands on some money; moreover she could cover part of the purchase price with a loan. Leo knows that he must keep his demands within reason. He wants to avoid compulsory aryanization. And to do something for Mitzi for all her years of faithful work. (He had a soft spot for her; it is said he was attracted to her as a woman as well: blonde, a bit of a tomboy but motherly too, despite or because of the fact that she was unable to have children. Malicious gossip—we'll soon hear it—suggests the two are having an affair.)

On the day after the house search Leo instructs a lawyer, Dr. Leopold Heindl, to draw up a bill of sale for the coal business which both parties sign on March 29, 1938, which is before the Property Transfer Office, the expro-

priation authority that has to approve every disposal of Jewish property to private individuals, begins to operate. The price for the business, including goodwill, depot, stock, equipment, arrears and debts, is set at 20,000 Austrian schillings (after the currency changeover that is 13,333,33 reichsmarks); the purchaser undertakes to pay it off in regular monthly installments of 400 schillings, starting on April 1. In a verbal appendix she agrees to bear all the expenses the Klagsbrunn family will incur until they leave the country, up to the full amount of the purchase price, less arrears and fees for the contract.

On July 14 Leo has to fill out the 'Register of the property of Jews as of April 27, 1938'. He indicates that he sold his business in March and possesses a house valued at 10,270 reichsmarks—according to the expertise of the Floridsdorf builder Franz Mikolaschek—in addition to that a life insurance with a surrender value of 2143 reichmarks, a pocket watch with a chain, a wrist watch, various items of silver, two carpets, two runners, to a total value of 920 reichsmarks, plus pictures and bronze pieces of no artistic value. There has been a mortgage of 2000 marks on the house since June 1928 in favor of Auguste Ferwerda, Amsterdam, that was deducted from

the purchase price. 'Aunt Gusti', as she is called in several letters from Maria Pfeiffer, is Fritzi's sister. She's married to a Dutchman, a senior employee of Shell, and will spend the years of the World War in Indonesia.

On August 5 the bill of sale of the property at 9 Pilzgasse (house and garden) for 10,000 reichsmarks is also drawn up. In it Maria Pfeiffer agrees to take over the mortgage and to pay back the balance of 8,000 reichsmarks "within at most five years from today's date, and until such time to pay interest at 4 per cent per annum." The Property Transfer Office approves the sale of the coal business on August 8 and informs Dr. Ottokar Czerny, the lawyer charged with the implementation of the contract, that for the acquisition of the real estate "approval is not at present required." At this point Leo and Fritzi Klagsbrunn and their sons have already left the territory of the German Reich—on August 7, 1938, three months before Kristallnacht and before the ordinances of the so-called Jewish Property Tax come into force. Maria Pfeiffer paid an aryanization duty, described as voluntary, of 1,000 reichsmarks in September.

As early as the beginning of July she asked the Vienna Property Transfer Office to expedite their "agreement

to the purchase of Firma Chemiker Leo Klagsbrunn, Vienna XXI, 9 Pilzgasse, which I took over on 17/3/1938." In the same letter she complains about "the spreading of false rumors" that give her a bad name with her customers, "yes, even with the District Party leadership." These, she said, were moves by the competition which she could only counter forcefully once the purchase had been recognized. As already mentioned, approval was granted one month later which, however, did nothing to stem the rumors. On September 28 the NSDAP HQ of Gau[3] Vienna, District HQ 9, Section of Economic Affairs, sends the report of the investigation by its Floridsdorf-Ringelsee District Group to the Property Transfer Office.

3. A name for an administrative region introduced by the Nazis.

8

MARIA ANNA PFEIFFER, b. 8/2/1903 and resident at 20 Franklinstrasse, Vienna 21, was employed as a clerk in the office of the Jew, Klagsbrunn, charcoal dealer, Pilzgasse, Vienna 21. She was a good friend of the Jew. According to the men and women who were employed there they were something more than just good friends. (Testimony of Frau Buresch and her spouse Theodor, 22 Floridusgasse, Vienna 21, Hans Kührer, 5-11 Fultonstrasse, Vienna 21.)

On the day immediately following the Changeover, Klagsbrunn, in the presence of his wife and after consulting a lawyer, sold the business to Frau Pfeiffer, concluding a bill of sale on the transaction. Where the Racial

German Pfeiffer could have found the money for this is unknown. According to the latest information, an engineer employed by Deutsche Reichsbahn, Vienna section, provided the finance as her fiancé.

The whole matter of the sale and takeover of the business looks to us like cover for something else, and that is how it is generally referred to in Floridsdorf. In this respect Frau Pfeiffer was forced to take legal action against Frau Schrammel, store-owner, 25 Floridusgasse, Vienna 21.

Furthermore the employee, Frau Buresch, also informs us that before her departure for Brazil (about 3 weeks ago) Frau Klagsbrunn took over the cash desk every day while RG Pfeiffer frequently accompanied the Jewish family to Vienna.

Apparently RG Pfeiffer's takeover of the business has already been approved by the Property Transfer Office. Furthermore she is now attempting to buy the coal chute of the Jew Stiasny and, strangely enough, is fully supported in this by the Reichsbahn while Party Comrade Hellmayer, coal merchant, Pilzgasse, Vienna 21, to whom it was promised and who has even made a relevant application to the Property Transfer Office, is not considered. What we are dealing with here seems to be a case of cronyism.

Whatever the case, we object to RG Pfeiffer, who has not done anything at all to support the Movement and was a friend of the Jew, taking possession of the Jewish firm and propose that a provisional management be put in charge of the Klagsbrunn Jewish firm.

A license to trade in wood and coal will not be granted to her on the part of the District Council.

Frau Schrammel informs us that RG Pfeiffer is said to have the intention of selling the business in two months' time in order to follow the Jews. We will keep an eye on this matter.

Heil Hitler!
(signature) Ringelsee District Group

9

Summoned for questioning on October 3, 1938, Maria Pfeiffer is clearly able to refute these accusations. But that is not the end of her problems. In May 1939 the Floridsdorf Tax Office informs her that Leopold Klagsbrunn has left behind unpaid taxes of 8376.85 reichsmarks, for which she, as the person who has taken over the business, is held liable. The major part of the demand—a round 7700 reichsmarks—consists of the tax on Jewish property and unpaid sales tax owed by the FAC, recently declared insolvent, which is being charged to the former president of the club. Since Maria Pfeiffer is unable to pay this sum, the tax office proposes having the house put up for compulsory auction. The justification for this

measure is that Leopold Klagsbrunn is named in the land register as due a sum of 8,000 reichsmarks—the amount the buyer undertook to pay in installments. At this Maria Pfeiffer applies for that entry to be deleted, supporting her request with a list of all the payments she has made so far. This makes it clear that she has already paid the purchase price, apart from a small remainder, by settling the seller's debts and contributing to his living expenses. Despite that, the Tax Office persists in its demands "since the inquiries conducted show that the value of the property taken over by you far exceeds the obligations of your predecessor." It is not until July 1941 that it adopts the view of the Property Transfer Office that at the point when the Jewish Property Tax came into force both the house and firm were in Aryan possession, and the obligation to pay the installments noted in the Land Registry no longer applied, as could be seen from the satisfaction piece sent by Klagsbrunn from Rio de Janeiro. "Therefore the distraint on the installments has no basis in law and only prevents the deletion of the entry in the Land Register, to the disadvantage of an Aryan, without any prospect of procuring the sums of money for the Tax Office." As well as that the Property Transfer Office recommended

that the Tax Office drop its demand for payment of the Jewish Property Tax, because "none of the Jew's assets were available," and concentrate instead on Leo Klagsbrunn's insurance policy. "Perhaps that asset is still tangible for the Tax Office."

Just one month later, on August 19, 1941, the Vienna office of the Gestapo strips the Klagsbrunn family of their German nationality, orders the seizure of their property, "both movable and immovable," to the benefit of the German Reich and, in agreement with the West Moabit, Berlin, Tax Office, which is responsible for the confiscation of forfeited assets, appoints the attorney, Dr. Stephan Lehner, as administrator. Once more Maria Pfeiffer has to furnish proof that she has already paid the purchase price for the house and business—in total 23,333.33 reichsmarks. Since the proceeds from the redemption of the policy—suddenly it only brings in 1481.40 reichsmarks—has already been called in by the Floridsdorf Tax Office in January 1942, all that he can lay his hands on is the Klagsbrunns' jewelry, for the sale of which the Vienna office the Gestapo collects 12.48 reichsmarks. After the deduction of bank fees and transfer costs, that leaves a balance of ten reichsmarks that

are credited to the account of the Senior Tax Officer of Vienna-Lower Danube.

At this point—the middle of May 1943—the Klagsbrunn family has long since settled in Rio de Janeiro. The journey there, however, took a whole seven months because of a long stay in Lisbon. We know that because twenty years later Kurt Klagsbrunn was to write under 'Proof' (of his claim to have fled Austria in August 1938) on a form of the Austrian Assistance Fund for victims of political persecution: "Passport no. A527775, issued by the police in Vienna June 13, 1934; withdrawn on September 5, 1938, by the German embassy in Lisbon." There, in Lisbon, he receives a letter from London in which Eva Rhoden describes the experiences she and her sister had during their last days in Vienna.

10

*O*N NOVEMBER 10 & 11 we were imprisoned. In Sinai's furniture shed. With all the Jews of Floridsdorf, from 2 years old to 100. 2 days without food and with nowhere to sleep. But hard work for all that. We had to unload 4 furniture vans with our own things. Even Liesl's bookshelf had been unscrewed and taken down. And when she quietly asked how they'd managed it, she'd always wondered, they were almost going to hit her. But Michel's sister gave one of them such a lovely smile, he didn't bother. I started crying uncontrollably when I saw all our dear, lovely things gathered there. I didn't know what I was starting with my tears. All the women began to sob, the SA bellowed, "Stop it!" It was horrible. The raging hunger

as well. And I already had a police record, on the same day I'd already been arrested by the police. And I spent an hour in the freezing cold of the loft before they found me at 7 in the morning. They arrested Mommy and Liesl at 4 but didn't find me then.—They grabbed all our clothes, all our money, in fact everything. The next day (11/11) they let us out. Mom went to an attorney (our house had already been sold, the preliminary contract signed and that was the day when we should have gotten the money) so Mom went to the one who'd arranged the sale. In the meantime Liesl and I borrowed 1 reichsmark from Aryans and went to the Gildemeester Organization. "A bathroom please!" We dashed in shouting that, we were so filthy. "We don't keep office hours." So away we went. I was so hungry I couldn't see properly. Two days is no joke. At least they let us wash our hands at the Jewish Community Center. The youth welfare worker gave us 5 reichsmarks and then she called me back in: "Evi, your visa's arrived." She even had the letter in her hand. I showed myself duly pleased, and there was I thinking my passport had been confiscated. And I had no idea where it could be. Then we bought a huge salami sandwich. And ate it as we went up Rotenturmstrasse to the Gildemeester. There we met Kurt Nagler

(at the moment he's in Dover Camp) and he bought us something to eat. Fruit, rolls, even liqueur chocolates. We stuffed ourselves and were glad that under his aegis we got into the bathroom. And we found something decent to sit on. We were almost happy. But with all the agitation and lack of sleep my eyes were funny and made everything look as if it was shimmering. We wanted to spend the night in the office rooms. We'd already lost Mommy. At 8 o'clock the senior officials threw us out and we stood, sobbing, in St. Stephen's Square with the pleasant prospect of spending the whole night walking round. But then Kurtl took us in, slept in the office himself and in the morning Frau Überall found us and invited us to her place. Two could also sleep there. We drew lots and I lost. So I went out to look for somewhere. There was one empty bed at Franzl Schnitzer's and we went to the Überalls' for all our meals. (I think Mommy's still there but they must be in great financial difficulties because of the contribution.[4] From us they're demanding the paltry sum of 30,000. Mommy doesn't even have 1%.) Then one of the Gestapo, who works at the Gildemeester Organization, got our passports back

4. The 'contribution', amounting in total to 1.2 billion reichsmarks, imposed on Jews as compensation for the damage caused during the Kristallnacht pogrom.

for us. Two days later we learnt that the visa is also valid for Liesl. But, of course, now we had no money for the tickets. Application to Gildemeester. OK, that won't be necessary with the Jewish Community Center. Queuing for a visa was 24 hours in the rain outside the English Consulate. Liesl was bleeding under her toenails. That's what it was like. Then Gildemeester ran out of money the day before. With great wire-pulling and 8 hours queuing we got the tickets and left Vienna the next day. Very tearlessly.

11

WITH HER LETTERS Maria keeps the Klagsbrunns up to date about things that have happened among their acquaintances and in the firm. At one point, because of customers who are behind with their payments, she wishes her former employer were there. "This is a time when you're urgently needed." Several times she even regrets having agreed to the purchase. The large number of regular customers aren't a lot of use to her, she says, because most of them are Jews, and the storage space she had at the freight depot was canceled straight away. She even once accuses Leo of having cheated her since—intentionally or because he forgot—he omitted to delete the obligation to pay the installments, which he'd

had entered in the Land Registry, which meant she'd had the authorities on her back for years and was burdened with extra charges. "I can't understand why you took me for a ride like that when I've always been so correct in my dealings with you."

Apart from that the relationship between her and the family continues to be as warm as ever. Now and then she complains that the Klagsbrunns don't write often enough and when they do it's too little. Right at the beginning she's worried about whether the crates with their effects have arrived because she had the impression that Hofbauer, the forwarding agent charged with dispatching them, seemed lax and money-grubbing. She asks whether a Bauer family has already written to them. "Max regularly asks after you. I think the man misses you a bit." To Fritzi she sends fashion magazines and a cookery book. She mentions that her boyfriend, Arthur Egger, whom she marries at the end of 1940 or the beginning of 1941, has pains because of his duodenal ulcer. That Egger joined the NSDAP—either to help his chances of promotion with the Deutsche Reichsbahn or because it's of advantage for her and the firm—we will only learn later from Grete Gabmeier.

From the above-mentioned list drawn up by Maria Pfeiffer of her payments to and for Leopold Klagsbrunn (various tax and health insurance arrears, missed installment payments, dues, lawyers' fees, back-payment of wages, dispatch charges, travel expenses for the Klagsbrunn family...) it is clear that the purchase price was also used to pay the expenses Leo's sister Sida and her daughter Franja incurred in connection with their plans to emigrate. Thanks to Grete Gabmeier we know that Franja was an actress in Vienna (and in the studio theater 'Literatur am Naschmarkt' that put on plays and reviews by dissident authors) and later on worked as a dental assistant in a small town near London. A postcard to Fritzi in Lisbon has survived, dated October 27, 1938, in which Franja mentions a school in England where she's applied for a job. "The disadvantage is that there's no other kind of work I'll be able to accept. But at the moment I just need to know where I belong." Between the lines she hints at how unbearable both her own situation and life in general has become in Vienna. "I try keep my spirits up but it is sometimes difficult. On top of everything it's very cold & gray & windy outside and & that gets me down."

It remains unknown whether Sida was eventually also allowed to emigrate to Great Britain. And what about Johann Frey, Franja's father? Had he already died, did he not want to leave, did he live apart from his wife and daughter? Unlike Leo's friend Max, we didn't find him in the database of Shoah victims compiled by the Documentary Archive of Austrian Resistance. According to that Maz Bauer was deported to Theresienstadt together with his wife Hermine on July 10, 1942, where she died on February 16, 1943. The date of his death is unknown.

12

LEO IS FIFTY-ONE, Fritzi fifty-two when they arrive in Brazil. Their sons are twenty-five and twenty. They have brought some effects with them from Vienna, linen, clothes, tableware, perhaps a few pieces of furniture and certainly a typewriter, which Leo bought in Vienna shortly before they left. Money? On Mitzi's list of payments there is, apart from travel expenses of 5300 reichsmarks, which were entirely taken up by tickets for the ship and plane, passports and visas as well as carriage for their luggage, just one such item, from the day of their departure: Paid in cash to Klagsbrunn for the emigration costs for two relatives and travel money for the Klagsbrunn family: 2850.—Certainly none of that will be left by the time they

reach Rio. However they manage to establish themselves professionally relatively quickly. Leo, presumably with the help of his brother-in-law, sets up a small firm—Lustra—making chemical products. Whether Fritzi works there too or brings in extra money from some other employment, is unknown. What we do know is that after the end of the war she is at home making aprons and other working clothes; Grete Gabmeier remembers that her aunt sometimes sends Frau Klagsbrunn material that is unobtainable in Brazil, or at least not of the same quality.

Their sons have to give up the idea of continuing their studies in Rio. After their long stay in Lisbon they can speak Portuguese reasonably well, so that they would have no problem following the lectures, but the exams they passed in Vienna are not recognized. They probably also find themselves forced to contribute to the family income as quickly as possible. Until he opens his first photographic studio Kurt, as he will later state, did "casual jobs" (the last in a travel agency). As early as April 1939, hardly a month after their arrival, Peter starts working as a sales representative for three local manufacturers of pharmaceutical products and perfumes, one after the other, then he sells essences used in making

perfumes for a US firm. In 1942 he marries Ingeborg Röschen Steuer, who comes from a devout Jewish family.

Inge was the last of her family to escape from Germany. At twenty years old, four or five days before the outbreak of the Second World War. For practical reasons, in order to learn the language during the crossing, she had booked the journey on a Brazilian passenger ship that just managed to sail, while the regular Hamburg Süd liner was stuck in the harbor. Her father had had a delicatessen in Berlin-Tiergarten. Salo Steuer is a war veteran and was awarded the Iron Cross 1st Class for his services to Kaiser and Fatherland. A friend of Inge's just calls him—contemptuously—the Sergeant. On the sabbath he refuses to take the bus and does the long journey from their apartment in Ipanema to Botafogo and the synagogue of the Associãço Religiosa Israelita, founded by German Jews, on foot.

He is not happy that, of all people, his daughter has set her mind on the frail Peter Klagsbrunn, who is indifferent in matters of faith, and insists he undergoes a medical examination before the wedding. The doctor certifies that he has a weak heart. Inge marries him despite that. In 1944 she gives birth to a daughter, Vera, and two years

later Victor is born. His father dies of a heart attack when he's six, leaving his widow not much more than an apartment in Copacabana encumbered with mortgages and a Ford Anglia that has only just been purchased.

First of all the car is sold. Then lodgers are sought to whom she turns over three of the four rooms. Thirdly she starts to work as a representative for promotional articles. She's hard-working, she doesn't spare herself, her nerves are always on edge. She smokes a lot. During the hot season between New Year and Carnival, when hardly anyone in Rio does any work, she makes exhausting business trips to Belo Horizonte and Manaus. Although she has no lack of admirers, she will never have another long-term relationship. She wants the children to have a better life when they grow up. Therefore she sends Vera and Victor to the Colegio de Aplicaçao, a model public school that operates under the aegis of the Universidade do Brasil, but persuades her daughter to follow it by training as a secretary. Thus Vera's desire to study law remains unfulfilled. Their mother wants Victor, however, to embark on an academic career. An attempt to have him instructed in the Jewish faith by the rabbi Dr. Lemle is torpedoed by Victor's impudence. When Lemle

sets his pupils an exercise to write down what they felt when they attended the synagogue, Victor's response is one word: heat. He enjoys the laughter from the other children and is unmoved by the rabbi's annoyance. At Rosh Hashanah and Yom Kippur, when he has to accompany his mother's family to the synagogue or, before it was built, to the premises of the Botafogo Rowing and Football Club, which have been hired for the occasion, it really is unbearably hot and humid in the overfull rooms. Victor always finds some opportunity to slip out unnoticed into the fresh air. At the Colegio he is in danger of having to repeat a year because of an over-strict teacher. Driven by his fear of the worry this will cause his mother, he spends a whole summer boning up on math and, to his own surprise, ends up among the best in the class.

13

FLORIDSDORF has suffered great damage during the Second World War. Pilzgasse is affected because of the air raids on the freight depot and the oil refinery. A bomb has landed in the garden of number 9, demolishing an extension built during the war together with the veranda, tearing the window frames out of the wall and blowing off the roof. The storage area beside the railroad has been completely destroyed.

"We have the laborious task of going back and starting from the beginning again with *everything*." That is what Maria Pfeiffer writes to the Klagsbrunns in her first airmail letter of April 15 ,1946. She has received no answer to a postcard she had sent a month previously.

This means she has to repeat all the news that's already a year old. Including the good news that Leo's brother Noli is well and has started to work. Noli, the dentist and inventor of a wax syringe at 34 Wienzeile, who left the Jewish religious community long before 1938 and married a Christian woman—of noble birth, as Victor was told by his uncle—who managed to protect him from deportation during the Nazi years.

The second piece of good news is that Mitzi's brother Josef is living in Floridsdorf again, together with his family. After the German invasion of the Soviet Union he had volunteered for the Red Army, had parachuted into Yugoslavia in the fall of 1944 and been wounded as a partisan with the Austrian Freedom Battalion during operations in Carinthia or Styria. Now he is head of the local section of the Austrian Communist Party. Her other brother is working for the state police that at that time is still under Communist influence. Her niece Grete is also employed there. "At the moment my husband is working as an electrician." (As an unskilled worker because he had been a member of the Nazi Party, as Grete Gabmeier tells us. Two years later Arthur Egger will be taken on as an official of the Federal Railways again and soon

promoted to a senior post in the planning and inspection department.) The Allied Control Commission, Maria Pfeiffer writes, has forbidden the discussion of business matters in letters abroad. Therefore she asks in a vague formulation for him to send "the confirmation from back then with a recent date, since I urgently need that confirmation." And she adds a second request: to inform her "how much I still owe you."

What this is all about becomes clear from Leo Klagsbrunn's written declaration of October 16, 1946, "that it was of my own free will that I sold my property to my employee Frau Maria Egger, née Pfeiffer, who had worked for me for many years. This sale had been planned long before my departure and had nothing to do with Aryanization. As proof of that one can take the fact that I sent a satisfaction piece for the money owing me on the house from Brazil." There is nothing in the letters that have been preserved to say whether Leo Klagsbrunn made a similar declaration regarding the coal business or not. Maria Pfeiffer's repeated complaint, right down until the early sixties, that the purchase of the house and business had "cost her dear," could be interpreted as an attempt to soothe her own conscience and to prevent her

friends in Rio from feeling they are still owed something. She mentions that through the currency reform she and her husband have lost all their savings, 65,000 reichsmarks. That is a considerable sum, almost three times as much as what was paid for Klagsbrunn's possessions, in current terms more than 200,000 euros. Victor thinks he remembers that Maria Pfeiffer sent his grandfather money now and then. In Vienna she has to combat the suspicion that she exploited Klagsbrunn's predicament. In January 1961, two years after Leo's death, she writes to Fritzi, "Since the time when we purchased the house and business in 1938 we've had nothing but animosity, first of all from the Nazis and now from Jewish organizations. Sometimes I'm in such depths of despair that I regret having agreed to purchase them in 1938. I admit that you, as seller, have lost out, because you had to emigrate, but I've come off even worse than you."

The fact is that over the years the sales of charcoal have been falling off more and more. Until now the main buyers have been smithies and scythe-works and they are closing down one after the other. There's no money to be made out of coal for irons anymore either. There's a minor upturn in the sixties when barbecues become

increasingly popular in Austria. As early as 1950 Maria and her husband bought the property at 15-17 Pilzgasse, on favorable terms because Floridsdorf is in the Soviet zone and the owners, Klosterneuburg Monastery, do not believe the Allied troops will ever leave Austria. On the plot there's a tiny house where two old women live. Maria Pfeiffer lets them continue living there. Only when the last one dies does she have the house pulled down and a three-story dwelling house built that has room for an office on the first floor. Behind the house storerooms with their own railway siding are constructed.

At some time around 1960 the ruined house at 9 Pilz-gasse is cleared to make way for a summer house. Maria Pfeiffer makes it available to Leo's sister-in-law Lisa, his brother Josef's widow who has to survive on welfare. In return Lisa helps out in the kitchen in the morning and looks after Grete Gabmeier's daughter, as her mother is now working in her aunt's office. Two years after her husband's death at the end of 1973, Maria Pfeiffer sells the firm to Kolkoks and retires. During her last years she, who was always surrounded by people throughout her life, complains about her lonely existence. No one ever comes to see me... When she dies, on January 2, 1980,

there is nothing left to recall Leopold Klagsbrunn's firm. But her niece keeps up the connection with Kurt Klagsbrunn, who after 1945 visited her and Maria Pfeiffer in Floridsdorf at least three times. Grete Gabmeier meets him again during a trip to Brazil. He didn't talk much, she says.

A letter of May 15, 1941, that one of the sons, probably Peter, sent to Hugo's widow in the USA, sheds some light on the reason why the family, as Maria Pfeiffer complained, were such poor correspondents.

14

*D*EAR LILLY,

 After a quite frighteningly long time I've finally gotten around to writing to you again. Of course our silence isn't due to the fact that we don't want to write to you, but simply and solely because we are all putting so much effort and concentration into our work that we have no time left for correspondence. You will quite rightly raise your European and perhaps also North American objections and say that one always has a bit of time left for writing if one really wants to. Not in Brazil. During the hot months here one has to take time to recover from the few unavoidable hours of work and quite simply cannot get around to answering letters promptly. Now that the summer is over

and the heat has gone, one has to deal with all the obligations that have piled up. During these cool days we do our thinking for the whole year, for during the hot days our brains seem to have shriveled up and to be having a very annoying summer sleep. During that time you perform your duties quite automatically, do what is most urgent, very slowly and sweating, half asleep while you're working, but you're only half asleep while you're sleeping too, for in that heat you can never sleep properly and you always wake up in the morning much more tired than when you went to bed the previous evening. You slave away and you still don't get anything done. The things people say during that time should only be taken with the greatest caution and you shouldn't bear a grudge against anyone for what they say, do, or omit to do during the hot period, for they aren't responsible for their actions then. However that, as far as I can see, sorts itself out after about five years and then the Europeans are acclimatized to the extent that they don't notice any difference between summer and winter, then they are the way they are now in summer for the whole year. That means we have about three years to go but it varies with the individual, it happens more quickly with some. Otherwise the country is a real paradise, magnificent to

look at and still relatively one of the cheapest countries in the world, though of course it's also suffering from the general rise in prices throughout the world because of the war, and that all the more so because the country's only a paradise as far as not spending very much is concerned, but it's equally modest as far as earning is concerned and in that respect is anything but paradisal.

All four of us are, thank God, in employment and we earn what we need. True, it's only enough for the bare necessities, but even that means a lot to us. We're also in reasonably good health, even though Mama does suffer from rheumatism most of the year, which is a great hindrance in her work, and Papa is often tormented by stomach pains, yet at the moment none of us is really ill and in this area almost everyone is a little bit off-color.

15

THERE'S NOT MUCH Victor can tell us about his father, who died early. That he was of a cheerful disposition, liked chatting, preferred sitting in the coffee house (the Cinelândia in the center of the town) to working, once tanned his hide, but only because his mother wanted him to. That when told his father had died, he, Victor, asked tearfully who was going to repair his toys now.

As a child, and also during his teenage years, Victor went to see his Austrian grandparents once a week in their house in Jaranjeiras, in the south of Rio, which he liked much better than when he was with his strict maternal grandmother, who was intent on keeping things in order. Grandma Fritzi, on the other hand, thought nothing

of crawling around on the floor when playing with her grandchildren and filling the bench with all the goods for a grocer's shop. She never wore jewelry, nor a watch either, even though Leo often came home with a bracelet or a watch for her. Solid gold, he liked that. He also valued food he was familiar with from Austria. Every day he bought, contrary to Brazilian habits, a quarter of a pound of fresh ham or cheese. He taught his grandson to play chess. After his death in July 1957 Victor was allowed to choose something from his possessions. Without hesitating he chose a large boxed chess set. His grandfather had once told him that every Austrian participant in a chess tournament in Russia had been given such a set. One of the selected players, he'd told him, had been a Klagsbrunn, an uncle or nephew of Leo.

With every move you have to know why you're making it. He'd taken his grandfather's advice to heart, Victor says, and passed it on to his students as a golden rule.

Victor remembers a regularly repeated scene from his childhood: he's playing in his grandparents' apartment and at some point his uncle comes home, smiles, waves and goes into his room. During birthday parties and other family gatherings Kurt would sit on one side

and remain silent. He wasn't really interested in people or, to put it more precisely, people only interested him the way objects did. And that, Victor thinks, is not uncommon among photographers. Marta remembers Kurt ringing at the door, many years later, smiling, coming in, looking at all the furnishings without a word, finally going toward her, smiling of course, though not to talk to her but because a detail on the frame of her spectacles had attracted his attention. He always wanted to know how a thing worked. He never went out without his hat and umbrella. He invariably had his camera with him, in a camel-colored case. He drove his car so slowly there was always a great queue crawling along behind him. In the neighborhood he was regarded as an eccentric but was liked, on the one hand because of his smile, which was erroneously interpreted as shyness and not because he didn't want close contact with people, on the other because of his European appearance. Brazilians, Victor says, had a sense of inferiority regarding Europeans. And the immigrants exploited that a little.

For a long time Victor didn't want to have anything to do with his uncle. That was because of his tendency always to have an eye to his own advantage. When he

took over his grandparents' apartment after Fritzi's death—she died on August 18, 1966—he offered his brothers' children a sum well below its market value. Victor was outraged but bowed to his mother's advice. I don't want to have to argue with Kurt about money, she said. Take what he's offering and let that be the end of it.

16

WHEN THE KLAGSBRUNN FAMILY arrives in Rio de Janeiro, the *Estado Novo* of the dictator Getúlio Vargas is eighteen months old. Justifying the coup d'état of November 10, 1937, in which he took over power from himself, with the danger of a communist conspiracy, Vargas abolished the constitution, subjected newspapers and radio stations to censorship prior to publication or broadcasting, and banned all political parties. Opponents are locked up, tortured or driven into exile. The regime lets the plantation owners keep their privileges, promotes the industrialization of the country, sets up state energy corporations and banks, and introduces labor laws on the fascist model, by which it wins over the new urban

proletariat. Vargas intensifies Brazil's trade relations with Germany, at the same time, however, issuing a ban on political activity by foreigners that is primarily directed against the population of German origin that sympathizes with National Socialism. Foreign languages are not allowed to be taught at Brazilian schools anymore and only native Brazilians are permitted as teachers. With its corporate-state model and latent anti-Semitism, which appears above all in restrictive immigration regulations for Jewish families, Vargas' dictatorship must have seemed like a variant of Austro-fascism with a tropical gloss to Leo and his family.

It is only in the early forties that Brazil changes course in foreign policy, entering the war on the side of the United States and relaxing censorship. In October 1945 Vargas is compelled to retire, and in the following year a new constitution is promulgated which guarantees freedom of speech and the separation of powers until the military putsch of 1964. Getúlio Vargas adheres to the constitution during his second period as president, from 1951 to 1954, as do his successors Juscelino Kubitschek and João Goulart. When Goulart nationalizes refineries, announces agrarian reform, breaks the USA's boycott

of Cuba and secures the support of mass organizations and the unions, he is overthrown by a coup d'état. That, sooner than in most other South American states, is the beginning of the reign of terror of the military that will last for twenty years.

In 1943, while Vargas was still dictator, the former Austrian ambassador, Anton Retschek, succeeded in getting special papers for the refugees belonging to the pressure group Comité de Proteção dos Interesses Austríacos no Brasil that identify them as Austrians and not Germans. Victor's grandparents and his father as well will certainly have belonged to this 'Committee for the Protection of Austrian Interests in Brazil' and taken part in its meetings. We do know that Kurt taught children and teenagers to play table tennis in the Club Austro-Brasileiro. So he wasn't always as unsociable as his nephew found him.

17

WHEN HE GOES TO UNIVERSITY in 1965 to study Economics, Victor is already convinced of the need for social and political change in Brazil. As he enjoys acting, he joins the Teatro Universitário Carioca. There he falls in love with Marta Maria Saavedra dos Anjos, who is studying Communication Sciences. Her father is a regular officer. Because he didn't take part in the 1964 coup d'état against the progressive president, João Goulart, he has been arrested by the military regime and, as punishment, transferred to the remote town of Manaus on the Amazon.

The Teatro Universitário Carioca had been founded by the Ação Popular, a Marxist organization with left-

wing Catholic roots, in order to gain influence among the students. In the face of the increasing repression, the young theater-makers rehearse plays that represent the political situation of the country through symbolic figures from the nation's history, popular legends and myths. One of them, Joaquim Cardozo's *O Coronel de Macambira* (The Colonel of Macambira), runs for three months in one of the city theaters.

It is a natural step from artistic to political resistance. The Ação Popular, that until now has made little impact in Rio's universities, is becoming more and more important. In 1969 one of its members, the Chemistry student Jean Marc von der Weid, is the president of the national students' union, the União Nacional dos Estudantes. In his limited free time Victor is busy supporting the action groups of the Ação Popular in the Chemistry Department. For every situation he has a quotation from Mao Tse-tung, whether appropriate or not. That arouses the mockery of the *cariocas*, who are known for their derisive sense of humor. The members of his cell call him *Filho do Mao*. Mao's little boy. Despite his carefree nature, being involved in political work means that he learns to be punctual, disciplined and to toe the party line. Later,

at a time when they are being openly pursued, he will, if possible, arrange secret rendezvous in Copacabana, the district he's known since he was a boy, not on busy intersections any more, but in quiet side-streets with little traffic, at the same time reducing the time to wait for his contact from ten to five then to two minutes. He agrees with the political slogan of the organization: For democracy and the distribution of land, against dictatorship! That is a demand which, in contrast to that of rival groups—Against capitalism! For socialism!—makes sense to the middle classes wavering between resignation and opposition. But the initially huge demonstrations with a hundred thousand participants draw smaller and smaller crowds. At the same time the number of those who see armed struggle as the way out of the country's crisis is growing. It is to be carried out by a small but determined nucleus of professional revolutionaries. The money needed for it comes from bank robberies. These provide an excuse for the dictatorship to abolish the constitution in December 1968 with the Fifth Institutional Act, close down both houses of parliament and forbid all political rallies.

In accordance with their idea that the revolution has

to start out from the countryside and not in the urban centers of population, the Açao Popular intends to organize the landless peasants. To this end liberated zones are to be created, on the Chinese model. The project demands long, patient groundwork. Like others of their comrades, Marta and Victor are therefore instructed to go to Maranhão in the poverty-stricken north-east of the country. So far they have financed their studies with part-time jobs, Victor as an employee of the Commisão do Plano do Carvão Nacional, the state planning commission for coal mining, Marta in the Brazilian editorial office of the *Encyclopaedia Britannica*. Even though the assignment seems risky, they agree in principle. They prepare for the operation, sell or give away the few things they possess and decide to get married—in order to convert the wedding presents into cash immediately so that they can set up a home in the place they're being sent to. But before they've made the final decision, the apartment, which they share with a few other comrades, is stormed by the police. On September 2, 1969.

18

F IRST OF ALL they are threatened with submachine guns, which are wrapped in plastic bags. Then they are handcuffed to one of the posts of the large, high bedstead in the colonial style that Marta has been given by one of her colleagues at work. The apartment is searched for weapons, though none are found, and piles of pamphlets, minutes of debates, outlines of strategy and notebooks are collected. During the next few hours Victor and Marta's comrades, seven or eight young men and women, arrive one after the other and are also handcuffed. Once it is dark outside, they are ordered to get undressed down to their underwear and taken out, two at a time, to a patrol car parked in the side-street. The drive to the center of

town takes about twenty minutes. The car is parked in the courtyard of a gloomy old building. Later Victor is to learn that it is the headquarters of the Departamento de Orden Política e Social, the feared political police. There the prisoners are herded up stairs into a long corridor, where they have to stand for hours, arms outstretched, Victor with a telephone directory in each hand as well. When, exhausted, he drops them, he is hit by a policeman and forced to hold them again. Then their details are taken. It's still dark when they are driven to a quay and bundled into a Navy boat. After half an hour it docks at a Navy base on Ilha das Flores, where immigrants used to be held in quarantine. Beside the jetty is a shed where the prisoners have to line up, faces to the wall, until they are interrogated individually. After that they are each put in a large cell on the first floor of a long building and once more interrogated and beaten one after the other. On the second day the interrogations are suddenly broken off. It is only much later that Victor is to learn the reason: in an audacious operation guerrillas of the Aliança de Libertação Nacional and the Movimento Revolutionário 8 de Outubro have kidnapped Charles Elbrick, the American ambassador, and CENIMAR, the Navy's secret service,

needs all available combat troops to find out where Elbrick is being kept. One month later Victor is put in a cell he shares with Carlos Frederico Frascari Morena, a member of or sympathizer with the Communist Party, whom he knows from the student movement. They are disturbed and frightened and don't know if they can trust each other. At some point or other the interrogations start again and it isn't long before Victor recognizes the signs that he is being prepared for torture: on those days he is left out when the food is distributed. The torture is carried out in an empty house the soldiers call Ponta dos Oitis at the other end of the island. Victor has water poured over him and is then hung up on the so-called parrot-swing, head down with the bar under his knees and his wrists bound to his ankles. Then he's beaten or given electric shocks. The worst is when the wires are attached to his testicles. It's so bad it can't be described, mustn't be described. First of all he is to reveal meeting places and hide-outs, later on the questions are mainly about the organizational structure of the Acão Popular.

The interrogations are conducted by two men, a corpulent blond naval officer, who calls himself Doctor Mike, and a gaunt, bespectacled policeman who answers

to Solimar. Sometimes an older man, probably also from the Criminal Investigation Department, is present as well; the prisoners say he's called Chico Pinote. Victor's assumption is that he and Solimar have specifically been charged with eliminating the Ação Popular. They gradually find out who has which function in the organization and take delight in supplementing the information they have extorted from one prisoner with facts they have in the meantime learnt from another. They also gradually manage to decipher code-names. But there are still a few people they haven't yet identified. Jean Marc von der Weid, for example, who had a false identity card when he was arrested, which means they have no idea that they have him in their power. They do know that he is the president of the of the National Students' Union, but they don't know what his area of responsibility within the Ação Popular is. Unintentionally Victor helps them make progress in this through a note they found in his apartment. He'd scribbled down a few words on it. The abbreviation JM with the comment that he is "our most important leader of the masses" puts them on the right track. One day Victor and the other Ação Popular prisoners are taken to Ponta dos Oitis where Jean Marc, blindfolded

and still wet from the water they poured over him before the torture, confesses that he is the man they are seeking. They use this confrontation to break the morale of the prisoners, so that they will cooperate with the police and the Navy.

Then Victor is locked up in what is little more than a crate that all the prisoners have to pass when they are taken for interrogation. It's probably done because of Marta, so that she will tell all she knows when she sees him in that terrible state. It's so small that Victor can neither stand upright, nor stretch out fully. At night he is shivering with cold, in the morning swarms of mosquitos descend upon him. Apart from that, his day is subject to the usual brutal routine. If he's given nothing to eat, he knows the parrot-swing is in store for him.

Eventually the prisoners are put together in cells that were originally dormitories for immigrants from overseas. Each one has a window just below the ceiling and a double door secured with a chain and padlock. When the prisoners in Victor's cell are taken out to go to the latrine or the shower, they can see their women through a gap in the door opposite, sometimes even whisper a few words, hear whispered words. Whenever they hear

that a new batch of prisoners has arrived, panic breaks out among them. They are constantly afraid that their tormentors, having acquired new information, will send for them to be interrogated again.

One day Victor is taken to the garrison office, where he finds Marta together with her father who, as a colonel, has obtained permission to visit his daughter, and the commandant of the Island's garrison, Naval Captain José Monteiro Clemente. He notices that Marta's father is somewhat put out because they pay no attention to him or the Commandant, but only have eyes for each other. Eyes to see what is unharmed in them, what has been done to them, what will haunt them in their thoughts or dreams. Or in poems that Marta will write years later, for herself, compelled by memory.

19

In prison, that's where she was.
And the prison was the world.
The prison kept the hours,
kept life in time.
The time for locking the cells,
the time for sunbathing,
the time for putting out the lights,
the time for waiting for the time.
The unreality of a place on the edge of the world.

Time roamed up and down between cell and corridor.
From one set of bars to the next.
The bunch of keys opened and closed the times.

Cold on your chest, on your hands, sweat, nausea.
The bunch of keys announced what was coming next.

Then, one day, habeas corpus.
The time for leaving the prison!
Freedom, from outside
the early morning of empty streets was dark,
dense, concealing the mystery.
FREE, she thought,
free,
to be more precise:
released into unreality,
set free,
but not yet free of fear.

She wasn't capable of complete freedom.

The outside was the place of other fears.
Of the silence of censorship,
of police sirens,
of people who scrutinize me suspiciously.
Why that apprehensive look,
that startled smile? I don't know why.

Sharp eyes on the look-out,
ears on the alert.
On which side did the fear grow,
in here/out there?

She stood up, went
without putting her foot on the floor
under the shower, heard the fear
in her clothes, felt the cold
in the mirror, the threat,
combed her matted hair and

dragged the prison out into the world.

20

M ARTA IS RELEASED FIRST, in stages that will almost cost her her life. From Ilha das Flores she is transferred to the normal women's prison in Rio. An attorney manages to get her and two companions freed. During the journey his car is stopped by a death squad, the attorney beaten up, the three women abducted. Hoods are put over their heads, they are dragged into a building and down a long corridor, then the hoods are taken off. They are in a bathroom with rusty fittings, smashed basins and broken tiles. There are people lying motionless on the floor. They are, as Marta is told, in the biggest torture center of the military police. There she has an epileptic fit. Hours, days pass before the hatch in the door

is opened. She shouts her name. Marta Saavedra is here! That night some men from the same squad come, with flashlights, put hoods over their heads again and drive the three women to a far-off, out-of-the-way dungeon that's covered in filth. There are no bunks, no lavatories, just a hole in the floor. The window is barred and boarded over as well. At some point or other they're taken back to the torture center, where each one is given a sheet of paper: sign, then you can go. They sign. At two in the morning they're pushed out of a police car in Botafogo.

Marta no longer has a passport, nor an identity card. She knows she can be abducted again at any time. So a few days later she goes, in disguise, to the Chilean consulate and asks for asylum. Her request is granted. She is not the only one. She spends almost eight weeks with other applicants in the servant's bedroom of the consulate because the Brazilian government of General Emílio Garrastazu Médici refuses them permission to emigrate to Chile. Then, however, members of the Vanguarda Popular Revolucionária kidnap the Swiss ambassador to Brazil, Giovanni Enrico Bucher. In exchange for him not only seventy political prisoners but also, after pressure from the Chilean government, the six asylum-seekers in the

consulate are to be flown out to Santiago. On January 12, 1971, they are taken to Galeão Aiport. Police vehicles with mounted machine guns escort the minibus to the runway.

Victor is released three months later. His sister once visited him in prison. During her visit he learns that, after his name appeared in the papers as a 'subversive' who had been arrested, she was dismissed as personal assistant to the head of the Brazilian office of Standard Oil. Later, in his mother's apartment, they don't talk about it any more. The fact is, Victor says, that Thea's career never really got going again. She was quite different from him, consumption oriented, earned good money and spent it like water.

Three months later Victor too sets off for Chile without a valid passport. As a Brazilian you can get as far as Puerto Suárez, the first town after the Bolivian border, with a normal ID card. His intention is to make his way on foot to Santa Cruz, in order to avoid check points, but the sweltering heat forces him to take the risk of traveling by bus and train via Cochabamba to La Paz and then on to the Chilean border, where he applies for political asylum. Once in Chile, in Arica, the carabineros hand him over to the local police, who put him in a cell, threatening to send him back to Brazil. It is only a call from the

presidential office in the capital that saves Victor. He is allowed to travel on, to Santiago, where Marta is waiting for him.

In Chile Salvador Allende has been president since 1970. During his time in office his country takes in victims of persecution from all over South America, including three thousand Brazilians. Many have not learnt a trade or profession, or had to break off their training because of the political persecution. They survive on money transferred by their families and have to endure the unfamiliar cold, separation from the place where they belong and the physical and psychological after-effects of torture and defeat.

Marta, too, initially finds it difficult to adapt to the present again. She feels a great emptiness inside, feels alien in her own tormented body, is panic-stricken at the thought of possibly never seeing Brazil again. She often recalls something an attorney once told her: there are people who rise above themselves in prison, become more mature, grow stronger, and others who are destroyed by it. An opinion, or prognosis, that makes her even more disheartened when she feels depressed. She makes an effort to develop her artistic talents, takes

courses in photography and film. For their final assessment in the film course the students use a story by the writer Antonio Skármeta, "The Cyclist of San Christobal." Marta contributes to the script, directs and plays the female lead.

Victor finds employment in the Estación Experimental La Platina, an agricultural experimental station outside Santiago. Unlike most of their fellow Brazilians, who stick together socially, Marta and he seek to make contact with the Chileans. They are amazed at the strength of the workers' organizations, their class consciousness. Neither, they think, was so well developed in Brazil. However, they also sense how deeply divided the society is, the determination of the opposition to use all means to overthrow the government. The majority of Victor's colleagues at work, at least the graduates among them, side with the 'mummies', as the reactionary alliance of big landowners, industrialists and army officers is called that is putting increasing pressure on the Popular Front government. When, at the end of June 1971, the Second Armored Regiment attempts a putsch, Victor suspects it's only the prelude to the large-scale attack on the labor movement. To the bloodbath, as everywhere

where the right-wing sees its supremacy under threat.

Immediately after Victor's arrival in Chile he got his mother to send him copies of the family documents and applied to the Austrian Embassy for a passport for himself and Marta. On the basis of the regulations in force at the time they have the right to Austrian citizenship. The officials promise to let him know as soon as the passports can be collected. That doesn't happen and in the turmoil of events he forgets to go and ask. Marta and he have heard from Rio that they have each been sentenced in their absence to six months in prison for subversive activities. And more news arrives, the most painful of all: that Victor's mother died on December 25, 1971, at the age of fifty and from a heart attack like his father. And he can't even fly there to attend her funeral.

Life was hard on her, Victor says, and with time she grew harder and harder. He remembers her impatience because, delicate like his father, as a child he refused to eat, at least when she was there, and her despair later when he neglected his studies more and more to concentrate on the political struggle. He also remembers how she would come home exhausted from her strenuous work doing the rounds of stores and businesses with her cases

of samples. And how she visited him in prison as often as she was allowed, and never forgot to bring huge food parcels. What neither he nor his sister can remember: that their mother ever kissed or hugged them. At least there was one final good conversation, on the evening before he fled the country, when he told her he intended to make his way to Chile to join Marta, a decision she accepted without a word.

Then comes the putsch of September 11, 1973. The attack on the presidential palace, the death of Allende, the mass arrests, shootings and curfews. For a whole week no civilian is allowed out in the streets. The state radio broadcasts demands for people to report foreign neighbors to the authorities. Brazilians are easily recognized by their lilting accent anyway. Despite all this, Victor imagines he and Marta are relatively safe. After all they did apply for permanent residence a long time ago. Only when a friend asks him about it does it occur to him that their papers are still with the police department dealing with aliens. Their friend drives them to the Mexican embassy, but as they approach the building they see that it is just being surrounded by military vehicles. They turn off and drive back home. The next day they try

the Argentinian embassy. One block before it their friend stops to let them out. In order not to arouse suspicion, they have not brought anything with them from their apartment. No case, no bag, no rucksack. Marta is wearing a headscarf, so that her blond hair won't give her away as a foreigner. They stroll down the street, holding hands, stop, kiss, take a few more steps. When they're only a few yards away, they start to run, through the gate and across the forecourt, which seems endless. Then they're finally at the door, in the embassy.

For the second time, Marta says, we'd lost everything.

21

WHEN THE PUTSCH HAPPENS in Chile, Argentina is ruled by the left-wing Peronist Héctor Cámpora. It is due to him that the embassy takes in unrestricted numbers of Chileans and foreigners who are seeking asylum. Eventually there will be six hundred people crammed together in the grounds and building. The sanitary arrangements cannot cope with the rush, babies, children and pregnant women are in danger of catching diseases. The United Nations' refugee relief organization sends an official to Santiago, an Austrian who gets his wife to inspect the Argentine embassy. She is horrified by conditions there and promises to see that Marta and Victor receive their passports.

In the middle of October 1973, shortly before or after Juan Domingo Perón's assumption of power in Argentina, the Chilean military regime allows the refugees in the embassy to leave the country. Victor and Marta are able to leave the country in an Argentine Air Force plane. During the flight the crew—all officers of the Argentine Air Force—talk about it being time to get rid of the subversives. We're going the open the hatch now and throw you down... Victor doesn't take the threat seriously. It will only come back to mind decades later when he reads reports of the Argentine Army's death flights with prisoners. The plane doesn't land in Buenos Aires, as they expected, but in Corrientes, in the north of the country. From there the refugees are taken to Posadas, not far from the Brazilian border. A whole night long they are interrogated, not just by the Argentine military but also by specialists of the CIA and people from the Brazilian secret service. For the first time in his life Victor sees a video camera, with which the interrogations are filmed. Then they are separated into groups. Victor and Marta go back to Corrientes where, as Victor puts it, they find their Argentine Schindler. That is, a left-wing Peronist official who, contrary to regulations, issues them papers

that allow them to get away, to Buenos Aires.

We didn't want to go away from South America, Victor says. Our attitude was: here we're close to Brazil; here we know our way around.

But the government gives them an ultimatum: you have one week to leave the country. To Europe, then, for want of other alternatives, and for preference to a country with a strong left-wing movement. One of their companions, who has also managed to get to the capital, persuades them to go to Italy. He has lived there for several years, he has contacts that might be useful for them. What have they to lose if they change continents for a while? And with Austrian passports no one can stop them.

They manage to survive in Rome for two years in precarious circumstances. Marta as a photographer and trade-fair hostess, Victor as a babysitter. From time to time the Chilean wife of a film director arranges for them to have walk-on parts in slapstick comedies. Then they have a piece of luck and meet the two Brazilian bishops, Hélder Câmara and Aloísio Lorscheider, who are in Europe denouncing the crimes of the military dictatorship. Lorscheider has good connections with the German

members of his order, the Franciscans, who obtain a three-month scholarship from the Catholic charitable organization Caritas for Victor. Thus they move to Berlin, where his mother came from. The first obstacle they find themselves faced with—quite unexpectedly for him—is the foreign language.

22

VICTOR: *At home my mother used to talk to my sister and me in German and we replied in Portuguese. I assumed I had a passive knowledge of the language. What nonsense. When we arrived in Germany I couldn't even understand the news.*

MARTA: *I started learning German while we were still in Rome. Then I took another intensive course, lasting three semesters. It provided a good basis but nothing more. There were Brazilians in Berlin who never managed to communicate in German throughout their time there.*

VICTOR: *What struck us was that language is a class barrier for the Germans as well. Not in Brazil. There everyone can understand everything. But German work-*

ers can't read papers such as the *Süddeutsche Zeitung*. *They're not written in their language. That's why ordinary people read the* Bild-Zeitung.

MARTA: *Only we couldn't even understand* Bild.

VICTOR: *And exile has other obstacles. For example I know people who survived torture and went to pieces in exile. It's not harder for them but longer-lasting. It was easier for me because of the internationalist experience of my mother, who had made the journey in the opposite direction.*

MARTA: *You lose everything, you have to build everything up from the beginning again. And that while you don't really want to do it because you intend to go back. I resisted that mental attitude. I told myself I had to be here a bit more, in Germany. I tried to make friends and foster the friendships, which helped to keep my curiosity about the country and its society alive. But at first I wasn't so clear about that. I saw myself as someone who was far away from her roots, from the life I'd imagined for myself, and I didn't know where to turn. Ten years of marriage in a condition like that aren't ten normal years of marriage. Routines haven't been established. Being in a foreign country keeps couples together. But so many relationships were broken off once the exile was over.*

VICTOR: *When there are difficulties you don't sepa-rate. I always compare it to a house of cards: you need someone to lean against if you don't want to collapse.*

MARTA: *We always set ourselves just short-term goals. We didn't have much time to assimilate our own experiences. For ages my own self-image was determined by what I'd been through. One thing was clear to us: it was right to have been in the resistance. It was right to fight for more justice, and our love of Brazil, of the people who have shown such courage, has never faded. I think we did everything it was possible to do at the time. That revolu-tionary movement in Brazil—that really was something. But I have the feeling that those who, unlike us, weren't involved, refuse to acknowledge its significance. That was my first impression when we went back to Brazil: that they don't really want us here. We could even sense that atti-tude among those who had sympathized with us at the time: it had all been for nothing. It had all been futile.*

VICTOR: *Another reason why it was difficult for us was because we didn't belong to any group. None of our former friends and companions had studied in Germany.*

MARTA: *We wanted to go back to Brazil. But we were also afraid of returning. Brazil had changed while we'd*

been away and we too were not the same anymore. The first five years were very difficult for us.

VICTOR: *It was complicated. Some people had returned from exile and wanted to tell the others what to do. That's not the way we are. And I know myself: I only go along with a movement that I can really identify with. There wasn't anything like that in the political sphere. As far as employment was concerned, there was. People didn't always understand that.*

MARTA: *I calculate that, including the time in prison, I was away from my country for seventeen years. That's too long. In the first place I couldn't talk about my life. Nor did I want to. I tried to be authentic. And to come to understand our country again.*

VICTOR: *Finding your place in a society again is a lengthy process. You have to proceed cautiously. I wasn't cautious. I was in a hurry. I was forty when I got there. It's still complicated. You tend to hold your tongue.*

MARTA: *Living a life that is a permanently provisional arrangement has left its mark on us. We are now at an age when everyone's well established. But we don't feel that we are. For our life has been different.*

23

I N WEST BERLIN Marta completed her studies with a master's dissertation on Brazilian *telenovelas* (soap operas) that was also published. Victor wrote a thesis on the development of agriculture in north-east Brazil after 1950 and then had a fixed-term position as assistant professor in the Institute of Sociology at the Free University. Their daughter Luana was born in 1977. When she was nine Victor and Marta decided to return to Brazil.

It was the right moment and at the same time the last opportunity in political, professional and private respects. After a slow and contradictory process, the military had ceded power to civilian politicians and in May 1985 the Brazilian parliament voted to change the

constitution, introducing direct elections for the office of president and posts of governor, granting illiterate people the right to vote and legalizing the Marxist parties that had been forbidden until then. Victor's contract with the Free University was running out. And Luana was of an age when she was well enough established to remember her German childhood and flexible enough to accept her parents' home as her own. Despite that, her parents' greatest concern was whether and how she would cope with the change.

Compared with Rio, or any other Brazilian city, they had found West Berlin an idyllic home. They could let their daughter go to the park or to see a friend by herself without worrying. Now that was out of the question because of the stark social differences, the violence permeating all levels of society and the immensely increased amount of traffic. The distances were greater, the hours of work longer, the salaries lower. It was usual even for the lower middle classes to employ servants at home and the relationship with them was, whether willingly or by force of circumstance, determined by command and obedience. To have a car of their own, which was more of a nuisance in West Berlin, was essential to take their daughter to

school, bring her home, drive her to birthday parties or sporting events, to manage the long distances to and between their places of work. Victor soon made it to assistant then full professor in the Faculty of Economics at the Universidade Federal Fluminense, while Marta struggled along with poorly paid teaching posts at several private universities until ten years ago, when she was appointed to a position at the Academia Brasileira de Letras, the Brazilian Academy of Language and Literature. Unlike Victor she is still working.

One year before they left for Brazil, in February or March 1986, the family went skiing in the South Tyrol. On the return journey they stopped off in Vienna. It was the first time Victor had been to the city. The three of them stayed for a few days in a guest house in the city center and went to the usual tourist attractions: St. Stephen's Cathedral, the Hofburg, the Opera, Schönbrunn Palace. Victor took the opportunity to have a look round on the other side of the Danube, in Floridsdorf, as well. It was familiar to him because his grandmother had talked more and more often about it the older she got. Floridsdorf. Floridsdorf and the summers on the old arm of the Danube. Floridsdorf and my Leo. Floridsdorf and

Mitzi Pfeiffer. But at that time he was still too bound up in the present to look into the history of his forebears. And I didn't have any idea exactly where they'd lived anyway, Victor says.

The last source for that would have been his Uncle Kurt. But he had completely lost contact with him during the years of oppression and exile. There was no question of his uncle ever having visited him in prison. Once Vera wrote to him that Kurt had turned up unexpectedly to ask what his, Victor's, address in Berlin was. Another time the telephone rang in their apartment in Berlin, Victor picked up the phone and said his name, at which an oldish woman's voice asked whether he was related to a certain Kurt Klagsbrunn. She had, the woman explained happened to come across his name in the phone book.

He's my uncle, Victor said.

A long time ago, she said, she and Kurt had been friends. More than friends.

And why did nothing come of it in the long term?

Oh well, the woman said. You know Kurt. He's a man who only thinks of himself, who doesn't want commitment.

24

KURT KLAGSBRUNN'S career coincides with the rise of photojournalism in Brazil. Journals such as *O Cruzeiro, Sombra* and *Rio Magazine*, based on British and North American models, start to appear and they are dependent on contributors such as him: they are aimed at a new middle class with a cosmopolitan outlook and a North American attitude about life. Journalism in which the picture replaces the message and is no longer merely illustration. Cool, detached, effective in an unspectacular way, deriving its expressive power from the gulf between appearance and reality. It entails irony, which at its best is the ability to capture the provisional nature of people and objects. Kurt Klagsbrunn is a master of that ironic photog-

raphy. Given that, it's no surprise that he soon succeeds in getting commissions for the New York magazine *Life*.

On a journey across seven or eight Brazilian states he opened up new territory for his camera. Later on he will accept a number of commissions that repeatedly take him away from Rio, to Brasília, for example, full of curiosity about the emergence of the new capital that was designed on the drawing-board. But first and foremost he is the great chronicler of Rio de Janeiro, which until 1960 is the seat of government, thus the center of political power, the economic capital as well, a seaport, a place of hope for hundreds of thousands of people leaving the countryside, a goal of national and international high-society plea-sure-seekers. With its bays and hills it is one of the most charming cities in the world; in contrast to São Paolo it has not banished the natural world from its confines and has a wealth of color that, paradoxically, is captured in the photographer's black-and-white pictures. It is also a city that, during the four decades of his professional life, goes through an immense transformation, architectur-ally, demographically, socially. When Kurt arrives in Rio it has 1.7 million inhabitants; in 1980, when he stops photo-graphing, over five million, not counting the suburbs. He

makes this change visible, documents the great building projects—the Avenida Presidente Vargas, to which whole rows of houses are sacrificed, the Maracaña Stadium, that is opened in time for the 1950 World Cup—has a look around the fashionable Jockey Club, liberates models and beauty queens from their sterile environment, records the tumult of the carnival in almost lapidary pictures. He retains the eye of the foreigner who notices things that seem ordinary to the locals.

It is not mere chance that, like him, other important photographers in Brazil also came to the country as young adults, as refugees from Europe: Thomas Farkas, Hildegard Rosenthal, Judith Munk. He and Thomas Farkas are friends and because Thomas' parents in São Paolo own a photography store, he never has any problem obtaining photographic material, despite the import restrictions during the war. For a while Munk was Kurt's business partner; his nephew, who met her in his grandparents' apartment and later often enjoyed visiting her, remembers her as an uncommonly lively, stimulating, gregarious woman. Right up to the end Kurt also works as a photographer for advertising and industry, which on the one hand brings in money and on the other reflects his penchant for getting

to the bottom of things, understanding how they work, observing them at rest and in motion.

Even though he frequently works for news agencies, he is anything but a reporter working under pressure. Rather he's a perfectionist, who spends a long time thinking before he presses the shutter release, and however casual and spontaneous some of his photographs look, they aren't snapshots. Or they are, only the observer doesn't see them as such. His portraits of artists and politicians have an almost relaxed immediacy, are unpretentious and vivid. You could imagine they are the work of someone who loves people, at least understands them.

He will leave his nephew an archive of 150,000 photos, slides, negatives and contact prints, and a big question about the gap between life and work: why do his indifference, his egoism, his mistrust vanish as soon as he looks through the viewfinder; why do we feel deceived when, after everything we've heard about him, we feel that we find in his pictures, which are never hurtful, the things he lacked in dealing with people: openness, involvement, tenderness. And a second question: what is more important, a proper life or an exceptional oeuvre. Does the one have to be achieved at the expense of the other.

25

WHEN SHE WAS A CHILD Luana was a real bookworm, Victor says. At the German school she went to in Rio, she spent many hours in the library. One day the woman in charge there told her that she knew someone else called Klagsbrunn. She used to work in the German bookshop, she said, and one of her colleagues had been Rose Walter, Rosina actually, the wife of the photographer Kurt Klagsbrunn. Luana told them about this when she got home, excited to have learnt about a relative she'd never heard of. And that was what made Victor go and visit his uncle.

That must have been in or around 1990. Whenever it was, Kurt had already had a stroke, could hardly use his

right hand at all and was trying to write with his left. He spent most of the time lying in bed, in his apartment in Rua Ribeiro de Almeida, the same street where the Klagsbrunn family had first found lodgings in Rio. Victor went to see him and his wife regularly, out of a sense of duty toward his last surviving relative and out of compassion, above all with Rose, who bravely bore his uncle's moods. He sucked her dry, Victor says. Once she confessed to him that she was finding it more and more difficult to cope with the housekeeping. Since Kurt's illness she was having to deal with financial matters, which was getting to be too much for her. It wasn't a great matter, Victor says, she just needed someone to give her a hand now and then. But Kurt had been unhappy that she had asked his nephew for help.

He volunteered nothing about himself, Victor says, I had to keep on asking. Nothing about his weekend cottage in Araras, in the mountains an hour's drive away from Rio. It would never have occurred to Kurt to suggest his nephew and family use it for excursions. He had designed it himself from plans in magazines such as *Do It Yourself*. I made the garden, Rose told him, Victor says, while he was always sitting around in the cottage tinkering about

with things. Using equipment he'd had sent from the USA, good tools from the forties and fifties. He'd even made the spare parts for his old car himself. He wasn't allowed to drive any longer because of his illness. So he made do with starting the engine once a week. For him selling the car was out of the question. He insisted on keeping all material things, Victor says. In one cupboard he stored half a dozen rotting tennis rackets, on his work-bench were three punctured tennis balls, in one corner old newspapers were piled up to the ceiling. He did have a television but seldom switched it on. He preferred to listen to classical music on the old crackling portable radio on his bedside table. Rose suffered from the heat but because he hated drafts he wouldn't even have a fan on the house.

When she died, like it or not he had to accept that his nephew took care of him. Victor employed two women who looked after him alternately. He persuaded Kurt, who had grown lazy in old age, to go for walks with him. To have a drink of water more often, for according to the doctor he was in danger of having kidney failure, but he could only get Kurt to sip at a cup of sweetened lemon tea now and then, pursing his lips, as Victor says. He had very bad teeth.

I'll take you to the dentist.

No, why, no one's going to see me.

It must have been a strange experience for him, Victor says: at the end of your life, to be together with a nephew you have nothing to do with…

Once Victor asked: you enquired about our address in Berlin. Why didn't you come to see us? Rose was afraid, Kurt replied. On a trip to Europe in 1999, after Rose's death, his nephew made a detour to Vienna to collect Kurt's victim's compensation pension for him (wire transfers always involved high bank charges) and on that occasion Kurt gave him Grete Gabmeier's telephone number. Victor and Marta went to see her, in Floridsdorf, in Pilzgasse, in the house Grete's aunt had had built after the end of the Allied occupation. It was a stimulating meeting but Victor still knew too little, about Austria and about his family, for him to be able to ask the right questions. The information his uncle in Rio let slip was only bits and pieces; it wasn't enough for him to work out the wider circumstances.

Their relationship improved during his last years, Victor says. And that was due to Luana. Kurt would confide secrets he'd never told his nephew to his grand-

niece and assembled a little dossier about as many rela-
tives as possible: a photo, a couple of letters, official docu-
ments, whatever he could find. He gradually started to
show some interest in Victor's professional activities. But
as far as his own memories were concerned, Victor still
had to drag them out of him. He only learnt that his uncle
had been called to meetings of the Central Committee of
the Communist Party from a historian. Soon after their
return, Victor and Marta had requested to see their files
held by the Political Police, and when Victor went to
collect the copies from the Federal Archives (one page
on him, fifty on Marta) the historian had asked him
whether he was related to Klagsbrunn the photographer.

Yes. Why do you ask?

I'm working though the CP archive and have found
lots of photos there. All of them have the name of the
photographer stamped on the back: Kurt Paul Klagsbrunn.

When asked about this Kurt said, yes, in the forties
he'd been a sympathizer of the Communist Party of
Brazil. Because at the time he'd had his studio in the
Edifício São Borja, the multi-story building next to the
Senate where the Party also had an office, the comrades
had brought him in to take photographs. Even later on as

well, after 1947 when the Party had been banned. Then, for security, they'd put a black hood over him and driven him to the secret meetings.

And was it you who put the stamp on the photos?

Of course, what d'you think. I've always been professional about my work.

Some things only came to light after Kurt's death. Such as the fact that immediately after his arrival in Rio, he started taking photos for the magazine of the National Students' Union that was antifascist and, with its mass mobilization of opinion, contributed to Brazil entering the war against Nazi Germany. In a 1942 newspaper article that Marta found in his apartment, it said that Kurt took part in all the activities of the Students' Union. He was regarded as a kind of honorary member, it went on; he spoke little—usually only as much as was absolutely necessary. "As you all know, I'm Austrian. Nazism drove me out of Austria and I ended up in Brazil. I have been helped here and made many acquaintances. The students as a whole have become my best friends. I think what you're doing is very important."

Kurt Klagsbrunn died on August 7, 2005, eight months after Victor's sister Vera.

He was the last of his generation, Victor says, and I had had no opportunity to care for my mother or my father. In the end I liked him. I didn't try to understand him. I felt very sorry that I couldn't do more for him. I never heard him say that there was anything in his life he regretted. I once asked him: Did you never want to have a child? And he said: No, actually not.

Actually not. As far as it has been possible to establish, of the eleven children of Ignaz and Johanna Klagsbrunn, who were photographed in front of a villa in Floridsdorf in spring 1904, only Leo had grandchildren and great-grandchildren. A current photograph ought to be placed over that one, in color and with, beside or between Victor and Marta, their daughter, their Italian son-in-law their two lively grandchildren. For a moment we can imagine we can see part of Klagsbrunn Villa in the background. But it's the façade of houses in a medium-sized German town where Luana lives with her family. Invisible on this picture are the threads linking times and continents. ▪

The Photographer
of Auschwitz

B EFORE HE SETS OFF FOR HOME, to the house,
weathered to a sulfurous yellow and sandy gray, on
the outskirts of Żywiec, where his wife is waiting for him,
watching television. Before he eases his stiff legs into the
official car of the Austrian consulate general, behind the
driver who the previous day told Jacek Buras the history of
his divided Polish-German family, in general outline. As
a farewell, then, Wilhelm Brasse shouts: And give my best
wishes to Austria. He has been there, twice, with a gap of
fifty or fifty-five years. Once to die and once to reacquaint
himself with it.

Now he slips onto the rear seat, closes the door, raises his arm in a friendly gesture, Jacek and I wave, then we withdraw from the mild, autumn sunshine into the excited whispering of the lobby of a four-star hotel in Kraków. How, I ask myself, can one pass on greetings to a whole country. It also occurs to me that I forgot to ask Brasse about Oskar Stuhr. Whether he knew Oskar Stuhr, even photographed him. Whether he had at least heard from him. After all, they both ended up in Auschwitz, against their will and yet of their own volition, it would have been in their power to avert the danger. Perhaps they only ran into each other afterward, on the occasion of a commemoration in the former camp or at a meeting of survivors from the Kraków area. Brasse has quite often been to such events and has no regrets about it, at least in that way he saw Hermann Langbein again, which pleased him immensely, even though he wasn't such a close friend as Rudi Friemel and Vickerl Vesely, of whom we will speak later.

Why not Oskar Stuhr then who, like Brasse, had no time for German blood and other Nazi stuff? Stuhr came from Vienna, lived in Kraków, and long before the German invasion of Poland on September 1, 1939, was

the legal adviser to the Jagiellonian University. As such he had seen it as his duty to accompany the venerable professors to Lecture Room 55, where they had to assemble on the orders of the Security Police. He was arrested along with them and deported to Sachsenhausen then Auschwitz. When, during registration in Auschwitz, it turned out that according to the Nuremberg Laws he was to be regarded as a German from the Reich about whom, moreover, there were no political reservations, the camp commander himself apologized for the mistake and informed him that he was free to go. Stuhr replied: Sir, that was not a mistake at all. I am Polish and I am staying here, with the other Poles.

The reporter Hanna Krall presented this episode twice: in the obituary of her friend, the film-maker Krzysztof Kieślowski, and in her doubly autobiographical novel *The Subtenant*. In the book she made the Austrian Stuhr into a German by the name of Staemmler who, after the liberation, has his name transcribed into Polish, Sztemler, which sounds Jewish to many ears and twenty-three years later leads to his children and grandchildren suffering anti-Semitic harassment; presumably Krall hoped this invention would improve both the book's aes-

thetic structure and its message. However in reality the man was called Stuhr, was born in Vienna and the author heard the story of his loyalty and pride from his grandson, the famous actor and director, Jerzy Stuhr, during a nocturnal chat about grandparents at Kraków Central Station, in the non-alcoholic restaurant there that shut down years ago.

But the memory remains of this Austrian who preferred to be a Pole rather than a German, just as it does of Karl Albrecht von Habsburg-Lothringen, an archduke of a branch of the Imperial house whose father had taken up residence in Saybusch in the eighteen-eighties. At that time the little town in the Beskids had 4296 inhabitants, occupied a picturesque situation at the confluence of the Soła and Koszawara Rivers, lay on the Galician Transverse Railway with a branch line to Bielitz, was the seat of a county administration and a county court, and had a few factories producing liqueurs, glue, cloth and paper. It was well-known for its brewery; beer from Żywiec, as the place is called in Polish, was also popular three hundred miles away in the Emperor's capital of Vienna. After the collapse of the Austro-Hungarian Empire in 1918, Saybusch fell to Poland. Karl Albrecht

changed nationality and henceforward served in the Polish army, ending with the rank of brigadier general. The German occupiers arrested and expropriated him, for they took it as proven that he had denied his racial ties and he felt no need to dispute that accusation. Detained by the Gestapo, then under house arrest, finally in a labor camp in Thuringia, he and his family (his wife a Swedish aristocrat; two daughters) survived the period of Nazi rule. They returned to Poland in 1945; however, after the Communists took over power they were compelled to seek refuge in Sweden.

Wilhelm Brasse was also Austrian, on his father's side. After the Franco-Prussian War his grandfather, a landscape gardener from Alsace, had settled in Saybusch/Żywiec, where he tended the extensive castle park to the complete satisfaction of the Archduke. His son, Wilhelm's father that is, worked as a precision engineer in the Brevellier-Urban engineering works and married a devout and great-hearted Polish woman who bore him six boys, Wilhelm, the eldest, on December 3, 1917. The others were called, in an almost perfectly balanced mixed-cultural sequence: Kazimierz, Rudolf, Marjan, Johann and Heinrich. Since the sudden death of the

youngest from a heart attack in the middle of October this year, only Wilhelm is still alive. He attended the high school in Żywiec, trained as a photographer after he left, and opened a photographic studio in Katowice once he had obtained his diploma. He couldn't complain about a lack of commissions, on the contrary, he was highly regarded for the care he took and for his ability to capture both the reality of the person whose portrait he was taking and the way they saw themselves.

As long as he was at school Brasse was not aware of any tensions between Poles and Germans. He had friends in both camps, neither side valuing their own kin more highly than those who were supposed to be foreign. It was only in 1936 that he noticed that, instead of a medallion with the Virgin Mary, more and more girls were wearing the bent cross on their necklaces. Until then he hadn't noticed any hatred of Jews, his five Jewish classmates at least had not been exposed to any animosity. After the war he was to run across one in the market square in Żywiec and that was for the last time, because his friend had decided to emigrate to Palestine, his ticket for the boat was already on its way.

Immediately after the defeat of Poland, the National

Socialist authorities set about sorting out the population according to racial criteria. With that aim in view, all inhabitants of the annexed districts as well as in the so-called Government General had to be registered in the List of Racial Germans. Their application was checked and anyone who was not classified as a professed German, of German origin, Germanized, or at least re-Germanized, was faced with severe reprisals. Like his brothers, Wilhelm was not interested in being recognized as a residual German of class 1 to 4, he felt he was a Pole among Poles, even if he had never been ashamed of his Austrian origin, and he wanted to fight for Poland's freedom. In the spring of 1940 he set off with a band of like-minded people to go abroad. Their goal was France, where General Sikorski was organizing the Polish armed forces in exile; they hoped to get there via Hungary. On March 8, in a village by Sanok, eight kilometers from the border, they were betrayed, surrounded and arrested. Brasse spent five months in a prison cell in Tarnów, then he was transferred to Auschwitz, along with 412 other prisoners. He can still say his prisoner's number there—3444—in his sleep.

Shortly before the train left, he and another Polish

patriot with a German name, Adler, were taken before an officer.

You have the choice. If you volunteer for the Wehrmacht, you'll be released.

No, said Brasse.

No, said Adler, who was murdered in Auschwitz one month later.

Brasse survived, in the first place by chance, just as every prisoner basically owed his continued existence to chance, in the second place because his profession was of use to the organization, and in the third place because he could speak German. In his section of the Records Department German had to be spoken, the SS officer Ernst Hofmann, previously a teacher in a small town in Saxony, had had a sign fixed there on which was written in clear, neat letters: 'Anyone who gabbles in Polish is a traitor and will be treated as such.'

From the very beginning the Records Department was headed by SS Oberscharführer (sergeant), later Hauptscharführer (sergeant-major) Bernhard Walter, who in the summer of 1944 was awarded a high decoration or some such cross of merit in recognition of his tireless participation in the selections on the unloading

ramp at Auschwitz II-Birkenau. According to Brasse, his behavior toward the prisoners under him was relatively decent, and when he was tried by a Polish court in 1948, the survivors of his section testified that he had treated them well, so that he was only sentenced to six years in prison. After his early release he settled in Fürth in Bavaria, where he worked as a projectionist, and it is presumably not going too far to assume that his years of service in the concentration camp were counted toward his pension.

The section consisted of ten prisoners of whom, apart from Brasse, only Taudeusz Brodka, from a village to the north of Warsaw, and Bronisław Jureczek, who mainly worked in the dark room, had had a thorough grounding in their craft. Their foreman was a certain Franz Malz from Stettin, a simple village photographer in Brasse's estimation. One of those who only take one exposure at a wedding because they don't want to waste film, who don't know anything about lighting and have never learnt to retouch a picture. As a communist Malz had immediately been arrested in 1933 and put in a concentration camp. In Auschwitz his mind or his survival instinct gradually went, perhaps he thought he was immortal after all those

years in which death had spared him; he talked too much and what he said was dangerous.

Franz, Brasse would say, you can tell me things like that, but not anyone else.

For instance the dream in which he saw the whole of Germany fenced in with barbed wire and Hitler, Goebbels, Goering, Höss and Himmler walking inside the wire, all in prisoner's uniforms.

Be careful, Franz.

But Franz told his barbed-wire dream to the canteen supervisor, who immediately told others and soon afterward a messenger announced that Malz had to report to the Political Department at once. With that his fate was sealed, in the fall of forty-three.

Brasse estimates that he took between 40,000 and 50,000 photos in Auschwitz, in the first two years almost exclusively of new arrivals, who were sent to him in the photographic studio straight after the reception formalities—head-shave, shower, clothes issue. Three photos of each, the first with cap on, looking up and to one side, the second without cap and from the front, the third in profile, for which the chair was turned by 90 degrees. The face of the person being portrayed had to be expression-

less. The rate at which he was compelled to work and the frequent presence of an SS officer made any communication beyond brusque orders—Cap off. Look in front. Off you go. And the next.—difficult. If signs of maltreatment could be clearly seen, the photos were usually taken at a later date. The time the work took and its intensity depended on the frequency of the convoys. When the first mass convoy from France arrived in the camp with 1100 deportees, the section had to work through the night. Then there were times when he could fulfill private requests from the guards and civilian workers. Not police photos but portraits and private pictures of SS officers, alone or with their wives, six postcard-size pictures for three reichsmarks, normal passport photos for 1.50 reichsmarks. For example, a series of Maximilian Grabner, the feared head of the Political Department, for his relatives in Lower Danube Gau. The request was for particularly good pictures, Grabner was very demanding.

Relax, Herr Unterscharführer, a little more to the left, now look at me. Yes, that's it.

Grabner was happy with the result. As was the young blonde, one of the so-called SS maidens who worked as telephonists and telegraphists. She wanted a half-length

portrait and posed in a thin tulle blouse under which her breasts could be made out, then she even took her blouse off.

For the family, as she explained to Brasse, it's to be something different.

After three or four days she came to collect the pictures. One week later she killed herself.

Her place of work wasn't far from the crematorium, Brasse says, opposite was the staff headquarters, on the other side the electrified barbed wire, she could see everything that was going on in the camp.

There was also photographic work undertaken on irregular terms, in return for 'charitable gifts', as Brasse puts it: the SS officers paid in goods, which cost them nothing. These deals were done behind Walter's back. Particularly useful was his relationship with Unter-scharführer Franz Schebek from Vienna, who supervised the food store. First of all Schebek had ordinary passport photos taken, then a series of postcard-size ones; in both cases he thought they were exceptionally good photos of him, so he soon turned up with another commission: Brasse was to enlarge some family photos.

Yes, but there's stuff I need for that.

What do you need?

Bread for the developer. For the fixer margarine. For the paper—

OK, that's enough. You'll get everything.

Two cubes of margarine and two pieces of bread, that made you rich, Brasse says. Moreover I used to pinch things from the food store. Whenever I took a copy to Schebek, something disappeared. He said, I know you're stealing but I just can't catch you. That meant that none of the ten men in my section had to go hungry.

One of them was a Jew, but only Brasse and Brodka knew that. The former had brought him into the section at the request of the latter simply by going to the boss: Beg to report, Herr Oberscharführer, we're behind with our work, we urgently need a specialist and I know of someone... Granted. The specialist was called Eduard Josefsberg. He'd worked in a photo shop in Lvov and after the war broke out had managed to acquire false papers that identified him as Aryan. When they went for a shower, which was at least two or three times a week because they were careful about hygiene in the Records Department, Brasse and Brodka kept him between them, for he was circumcised and none of the SS should see that.

Fifty-two years after the liberation there was a reunion of the three camp photographers, in Sweden, where the two others has settled. Brasse had visited Brodka, who had told Josefsberg, and they spent a lovely evening together. Two days later Josephsberg's wife called Brodka, moaning and begging him to leave her husband in peace; he was ripe for the nut-house, she said, it must be because they'd been talking about Auschwitz until late into the night, since then he'd been driveling on and on that he'd betrayed the Jews there and wasn't fit to go on living. Eduard Josefsberg, who called himself Kowalski in Malmö and probably died long ago.

Brasse could have coped with the daily routine. The countless police photos. Cap off, look straight ahead, turn left, etc. But they, not counting the private ones, were not the only photographs demanded of him. Soon after the first mass convoys of Jews had arrived in Auschwitz he was forced to record the pseudo-medical experiments of the SS doctors Josef Mengele and Eduard Wirths in pictures. Wirths, who had taken it into his head to develop a method of early diagnosis of cancer of the cervix, even had a gynecological chair brought into the studio, in which women were compelled to undergo colposcopical investi-

gations. The camera was lurking between the stirrups and behind it Brasse's eye. Mengele, on the other hand, was after people of restricted growth—brothers and sisters, sets of twins, children—whom he subjected to terrible mutilations. The third, Friedrich Entress, had a pathological passion for unusual tattoos, which he cut out of his victims' bodies and kept in an album; but first of all Brasse had to photograph them on the person while they were still alive. Johannes Kramer, fourthly, wanted to have all the phases of starvation documented; he would send emaciated prisoners to Brasse, who knew that immediately afterward they would be killed with an injection of poison.

Sometimes he tried to delay their death. In such cases he would claim that the photos hadn't come out satisfactorily and had to be done again. On the other hand he sometimes tried to shorten their sufferings, because they were beyond help anyway. For example, two of his neighbors from Żywiec called Enoch and Wachsberger (Wachsberger had kept the inn on the station square), who were getting weaker and weaker by the day, even though he had for a long time made an effort to feed them. When it became clear to him that they were lost, he asked a prisoner from Block II, a killer called Wacław Rudzki, who was as accom-

plished as he was nasty, to bring their lives to a swift, painless end. By a blow with the edge of the hand on the carotid artery or a sudden twist of the head, a broken neck.

In the camp, Brasse says, no one died, they all just perished like animals.

And he adds a phrase that he weaves in at the most impossible points, but here it's in the right place: That's what things were like.

There is one of Brasse's photos that has gone all around the world. Everyone who has dealt, however superficially, with Auschwitz and the extermination of people and the Nazi regime knows it. It shows four Jewish girls, naked, emaciated until they're nothing more than skeletons, looking at us with big eyes. Four thirteen-year-olds who are shortly about to die and are immensely ashamed of their nakedness, before each other and before the man looking at them through the camera. Brasse says he attempted to help them overcome their shame, which weighs on him like a reproach, he kept his distance, in order by that very means to be close to them, he spoke to them tenderly, gave them a piece of bread, that they grasped greedily and devoured.

That was the moment when I cursed God. And my mother for having given birth to me.

It was this picture above all that appeared to him after the liberation whenever he looked through his viewfinder. Until he finally put his camera away forever.

One day in January 1945 an agitated Hauptscharführer Walter dashed into the room.

Brasse, Jureczek, quick, the Russkis are coming, burn all the photos at once. Prints, negatives, index cards—into the stove with them.

Brasse obeyed. He opened the first drawer, took out several packets and threw them into the stove. But they wouldn't burn. It turned out that the German firms were already delivering negatives of non-combustible material. Walter, horrified, started to poke the fire; after five or ten minutes he ran off, at which Brasse pulled the scorched negatives out of the stove and poured water over them.

I managed to save that lot. About three-quarters of the material has been preserved. Part of it was later found in other camps. How did it get there?

On January 21 Brasse left the camp with the last evacuation convoy. They had to do the first 52 miles on foot, then they were loaded into open freight cars. Brasse had taken his precautions: he had his own prisoner's photo with him and also the pictures of his uncle, one of his

mother's brothers who had been gassed in the camp after he'd survived the typhus epidemic, during which Brasse himself almost died; he'd already been dragged, naked, out of the sick bay but his boss had gone to see Entress, the camp doctor, personally: I need Brasse, you're to make him better. So he had the three photos of his uncle as well as an Agfa movie camera and a Zeiss Extra camera. As the train to Mauthausen crossed the bridge over the Danube, he threw everything in the water.

If they'd found that on me, I'd have been killed at once.

In Mauthausen Brasse spent a week or ten days in the quarantine block, then he was sent to the outer camp at Melk, in the former stables of the monastery where, in the open air and at freezing temperatures, he had to work for the firm of Stiegler & Russ digging ditches and holes, erecting fences and huts to house the new mass convoys of prisoners, who were dropping like flies. From one particular spot in the camp a small piece of the Danube could be seen. He could feel he was getting weaker every day. On April 14 or 15 he was transported again, to Ebensee and then on to Attnang-Puchheim for clearing-up operations because the station had been

bombed shortly beforehand. He fell ill with gastric fever, only weighed 90 lbs. when he was five-foot-nine tall; gradually he got used to the idea that he was going to die. But on May 6 he was liberated by the Americans, who took him to Lambach, to recover in a military hospital.

There was the possibility of emigrating to the USA. For anyone who could show that they had relatives in the United States the crossing was free. Brasse remembered that a sister of his mother had gone there before the war, but he wasn't attracted by the idea of following her. His whole being was set on a return to Poland. In Auschwitz he'd had the opportunity to have a look at his file in the camp commander's office. There was a note in it that an aunt, who had married into the family on his father's side, a real Pole-basher, as Brasse said, had made very unfriendly comments about him to the police: "As a fanatical Pole it will be better if he stays in the camp until the end of the war." For that and other offenses she was sentenced to six years in prison after the war. Later she emigrated to the Federal Republic. And her nephew set off for Poland on July 10, 1945.

I wanted to go back to my profession. Work as a photographer again. But there was the memory of the photos,

above all the one of the four girls.

In Żywiec he became friendly with a young woman he'd known from before the war, their friendship turned into love and their love produced two children. He told his son about what he had experienced and seen in the camps, he traveled around Austria with him, as far as the Swiss border and back, through the former places of suffering, the delightful surroundings of which he could now enjoy: Melk, the imposing monastery, the Wachau, the Salzkammergut, Ebensee, the view of the rocks in Lake Traunsee. His daughter knows about this as well, of course. But he didn't go into the details with her. The sufferings of the children, of the girls, of the young women in the camp brothel whom he also had to photograph. By chance he saw one of them again in Warsaw, in the streetcar; he was going to go over to her and say hello but she gave him a sign: keep away from me, don't talk to me.

When it became clear that it was all over with photography for him, he looked around for another profession, a way of earning a living that under no circumstances would place him in a moral dilemma ever again. An occupation that was so ordinary that the question of the relationship between innocence and involvement

would never arise. Together with his wife he began producing artificial skins for sausages. They made, as he says, a pretty good living out of it.

THE ONLY CHEERFUL PHOTO from Auschwitz, with a promise of happiness, has stayed with me for fifteen years. Wilhelm Brasse took it in the Records Department on the morning of March 18, 1944, after the civil wedding of the Austrian, Rudi Friemel, who was under preventive detention, and the Spaniard Margarita Ferrer, who on this occasion was allowed to stay in the camp for one day and one night, accompanied by their child, who was three years old. I found prints of this photo in Vienna, Madrid and Paris. The description of these events in a posthumously published sketch by Margarita suggested the photographer was a prisoner from Vienna who had long since died. That is what it says in my story about *The Wedding in Auschwitz*, which was published just four years ago. I have only heard about Brasse now, with the appearance of the Polish edition, but in reality our acquaintance is a result of the invisible threads running through places and times:

On May 19, 1944, the Ovici family arrived in Auschwitz in a train-load of Hungarian Jews. They were ten

brothers and sisters who came from Transylvania and had appeared in concert halls and vaudeville theaters in Budapest. Seven of them, all of restricted growth, performed songs and sketches under the name of *Trupa liliput*, while the rest, two women and one man, played klezmer music. These three were no different than other people, apart from the fact that they had short arms and legs like their brothers and sisters. But precisely that was what aroused Mengele's interest. He subjected them to a series of experiments, the effects of which Brasse had to record with the camera.

Fifty years later a woman from the disabled movement, Hannelore Witkofski, was interested in the fate of persons of restricted growth in German concentration camps. She went to Israel to visit Perla Ovici, the last survivor of the klezmer trio, and it was from her that she learnt the name of the photographer who had documented Mengele's experiments. She found Brasse's address through the Auschwitz Memorial Museum, went to Żywiec and questioned him on camera about the victims of Nazi medical research. The Polish documentary journalist, Irek Dobrowolski, happened to see the interview, about six years ago, Brasse says, and decided to make a

make a film about him, Brasse, the portrait of a portrait-
ist, so to speak; and *Portrecista* is the title of the film that
Dobrowolski made, with his own equipment and at his
own expense because no one was prepared to finance it,
but since it was shown this year on Polish television and
at film festivals abroad, Brasse's telephone in ul. Sienkie-
wicza keeps on ringing and people he's never heard of ask
him whether he might have photographed their parents,
grandparents, uncles or aunts, cousins, etc. in Auschwitz,
perhaps he can remember. He is happy to receive such
calls, he helps wherever he can, though he advises them
to call in the morning, for after lunch his wife switches
the television on and it's quite possible he wouldn't hear
the telephone ring.

This is what Jacek Buras tells me during the drive
from Kraków to Żywiec and I'm looking forward to finally
getting to know Wilhelm Brasse. Jacek made a great effort
to see that my book was published in Poland, on a hint
from the Austrian writer and translator Martin Pollack,
and was quite surprised when, one evening, the wedding
photo from Auschwitz suddenly appeared on his televi-
sion, immediately followed by the old man who had taken
it and whom we are now going to take with us to Kraków.

Such is chance.

Thus the last piece falls into place. The photographer and the photo. His Austrian grandfather from Alsace and his Austrian friend in the camp. The other Austrian whom Buras has brought along and who has written about that friend.

(That's all correct, Brasse will say after reading this and I won't be unhappy to hear him say that.)

Rudi Friemel was not the only Austrian he grew fond of in the camp. Vickerl, real name Ludwig Vesely, Brasse calls him Vicky, also came from Vienna. They worked in the carpool, Rudi as foreman, Vicky as his assistant who dealt with any paperwork. The two had only become acquainted in the camp, in the winter of 1942 after Rudi, as a well-qualified motor mechanic and with his both self-assured and engaging manner, had risen very rapidly in the hierarchy of prisoners. Brasse profited from that; if new arrivals from Żywiec needed to be allocated to a good section, he knew he could rely on him. He knew that Rudi or Vicky would see that it was done. From conversations and hints he knew the story of Rudi's life, at least in rough outline: fought against Dollfuss' dictatorship in February 1934, was a political prisoner until 1938,

then joined the International Brigades in Spain, where he met his great love, whom he was finally able to marry in the camp. Brasse also knew that in Vienna there was a son from his first marriage as well as the other one, of course, the comical little fellow he'd photographed. Rudi was allowed to let his hair grow and borrow a suit from the clothes store so that just looking at the photo one would never have guessed it was taken in Auschwitz. Also because his wife was so beautiful and well-groomed and because no one could imagine a wedding in Auschwitz anyway. Brasse recalls that the camp orchestra played the Wedding March.

For me that was a special story, something out of the ordinary, the only photograph I enjoyed taking.

Then he happened to hear of a romance between Rudi and one of the secretaries in the register office. He never saw any evidence of it himself. Not much will have happened, no more than happened between him and Anna, a girl from Tarnów who was Mengele's secretary, but they were in love and swore to each other they'd get married after the liberation. After he returned from Austria, Brasse took the train to Tarnów as soon as possible and looked for Anna, but she was engaged, to another man.

What about our promise, he asked.

Oh, of course. I thought you hadn't survived, she said.

A few times they went out together as a foursome, Anna and her fiancé and he with his future wife, but then they stopped, realizing that both their partners felt uncomfortable about it.

Rudi was cheerful, Vicky was cheerful, that was what the women prisoners liked about them, and the men as well. Their sense of humor, their self-assurance, their readiness to help, their confidence. Brasse spends a long time looking for a word that does justice to both their political stance and their stature as human beings. Social democrats, he says hesitantly, with a longish pause between the two words, but he's not happy with that characterization. After a while he tries again. Genuine socialists. Then again: real humanists. (In fact they were communists, Vickerl always, Rudi since 1942 at the latest. But who wants to risk praising communists as models, as irreproachable, especially in Poland. Moreover the suspicion that the word 'communist' has lost its positive sense forever is not entirely unfounded and in that case Brasse would be quite correct.)

Once Vicky showed him a pistol. That was an indis-

cretion but also a great token of trust.

We'll have to defend ourselves, he said, when they start to liquidate the camp.

Brasse was roped into the resistance network as well. Using the information collected in his section, for example, he made lists of the dead. His fellow-countryman Stanisław Kłodziński passed them on to civilian workers who had connections with the partisans outside. For reasons of security each of them only knew what was absolutely necessary. That was why he didn't hear about the escape attempt of four Poles and one Austrian, at the end of October 1944, until after it had failed. Two months later, on December 30, the survivors of the attempt and their assistants, Friemel and Vesely, were hanged on the parade ground.

It was terrible for him to have to watch. Their death on the gallows a tragedy. Ernst Burger, Bernard Świerczyna, Piotr Piąty. Good comrades, all three of them. Piąty had worked in the dental ward, Burger slept in the same block as he did, 4 or 5. The worst, however, was the loss of Rudi and Vicky. Normally executions were carried out in silence, without incident, all that was to be heard the commands of the SS and a rustling when the 15,000 pris-

oners of the original camp took off their caps at the same moment. But to their very last breath those five shouted slogans that could be heard right across the parade ground. Long live Austria! Long live Poland! Down with the brown scum! Three cheers for the Soviet Union! He can remember that quite clearly. And that Vicky, the youngest, shouted loudest of all.

It would have been something if the two of them had survived. If they'd still been alive. Then he would have visited them, a little detour on his journey to Melk and Ebensee. And then I wouldn't be asking what to make of Brasse's words of farewell, who or what he includes in the Austria to whom he asked me to give his best wishes.

TWO PHOTOS are to go with this report. The one a still from Dobrowolski's film: Brasse with the picture of the four girls that kept on appearing in his viewfinder. The other of the wedding: Marga and Rudi and between them little Edi, who died two years ago in France. The gulf between the two photos, the question whether each of them is incomplete without the other.

The third photo I am just going to describe in the hope readers can visualize it in their mind's eye: a snap-

shot in Brasse's front garden, taken by the ever slapdash Jacek Buras and therefore blurred. You have to blank me out, I'm irrelevant. What that leaves is an old man, bent but by no means infirm, in a dark-blue blazer, his hearing aid stuck in his right ear, his beret at an angle on his head, in the middle a large, fleshy nose. To his left a piece of the wall of the house, weathered to a sulfurous yellow and sandy gray, behind it (invisible) Frau Stanisława, five years younger than him, who is said to have been very beautiful sixty years ago, and a little jealous as well, and likes to switch on the television in the afternoon, which is why Brasse advises... But that's already been said. ▪

Tschofenig:
The Name Behind
the Street

That was something they were all exposed to:
—Manfred Franke, Mordverläufe

T HAT WAS SOMETHING they were all exposed to: Some had a foreboding about it, even before it happened. They heard it in the night when it did happen. The following day they saw things that indicated how it had happened. They made a mental note of the place where it had happened. When everything was over, they went

home. Then they indicated the place to the others, who hadn't ceased to hope that it wouldn't happen. These latter started to dig, cautiously and quietly, as if by that they could undo what had happened. After they'd turned the earth over with their spades a few times, they came upon the bodies. Gisela was at the bottom, doubled up, in her stockinged feet and with one empty eye socket. They dispersed and talked about it. That's how some people heard about it; few were those who passed it on.

They talked about it: to Hermann, for example. It isn't the first memory connected with his mother. In the first he's lying beside her in bed. It's dark and he can hear the rustling and scurrying in the joists above their heads. That woke him up or stopped him getting to sleep. His mother told him that it was mice. No need to feel afraid, they won't hurt you. He also remembers a boy, three or four years older than him. He doesn't know whether there were other children there or not. There probably were. During the day he played by a stream with the boy. He showed him how to catch crawfish in the shallow water.

That was in Möltschach, outside Villach, Carinthia, in the house of the Tatschl family. That was where his mother was arrested by the Gestapo. But he's unable to

remember that. He doesn't know what happened next, either. I assume Frau Tatschl took him to his grandmother, Theresia Tschofenig, in Villach-Völkendorf, who will then have informed the Taurers, his maternal grandparents, in Linz. Klaus Taurer was an engineer on the railroad, Gisela's brother Albert a traffic superintendent with the railroad, it wouldn't have been difficult for them to collect Hermann in Villach the next day. They were familiar to him, after he was born he and his mother had lived with them, in Füchselstrasse, Block J, Staircase 2 of the railroad development, two rooms whose third-floor windows opened onto the track of the Western Railway.

In July 1944 Gisela had gone with him to Carinthia, to find a safe refuge, she'd probably been given a sign that she should disappear for the time being. Her mother Helene was relieved, thinking perhaps that Gisela, out of consideration for little Hermann, had finally given way to her urgings and abandoned her subversive activities, about which she knew nothing specific, only that there was something going on that couldn't be discussed. Her arrest in or near Villach, which Hermann cannot remember, took place on September 26. It is uncertain whether Gisela was immediately transferred to Linz or

interrogated while she was still in Carinthia, or even (as her friend Resi Reindl claimed) in Vienna, but if she was, she didn't stay there for long, for her first card to her mother from the Kaplanhof women's prison in Linz is dated 9/30/1944.

Dear Mother,

 Please send me clean underwear and my suit, gray winter coat, soap, toothpaste, toothbrush, comb, sanitary towels & the girdle for them, tracksuit. Mother-in-law should send my winter things. You can hand it in here at any time. A food parcel would be welcome as well. Please take care of my little boy. Don't forget handkerchiefs and stockings.

 You've got something to worry about again, Mother dear. Best wishes to everyone.

 Gisela

 A warm nightie.

SHE'S NOT THERE in his next memories. In them he's in Linz, out in the open air, during the last weeks of the Hitler years. Near the building in Füchselstrasse a pond has been dug, to provide water for fighting fires

after air raids. Together with another child, Hermann is sticking little pieces of wood in the ground beside the pond, when he suddenly notices soil spurting up beside him. Puzzled, he looks up and sees the fighter pilot who is firing at them. It's only now that he hears the engine noise, the rat-tat-tat of the aircraft's gun as well. And a few days before or after that he's standing by the air-raid shelter outside the house; it sticks up out of the grass a bit and the soil all around has been piled up and smoothed out to make a little slope on which a neighbor, who's called the assistant air-raid warden, is lying and shooting with a machine gun at people floating through the air, hanging defenseless on strings under an umbrella. Hermann remembers that. And he remembers the designation assistant air-raid warden as well. It occurs to him that at the end of the war their neighbor disappeared. It was said that he went to live in Urfahr, on the other side of the Danube, in the Soviet Zone of Occupation, where he assumed he'd be safe from the investigations of the American military authorities. Hermann must have picked that up from his grandmother or his Aunt Leni.

The fourth memory still hurts even today. Holding his grandmother's hand, he's going to Schörgenhub Camp

where his mother is imprisoned. It's spring, the end of March or the beginning of April forty-five. His grandmother's made a savory blancmange ("don't ask me what a savory blancmange is," Hermann will say sixty-three years later) and asks the guard at the gate (in a steel helmet and carrying a rifle, he will recall) to be allowed to hand over the blancmange for Gisela. The man shakes his head and sends her away. Brusquely and with a threatening gesture because Helene Taurer has tried to get him to change his mind. A long way away, behind barbed wire, next to a hut, Hermann sees a woman waving, her arms stretched far above her head: his mother Gisela. And he's happy because now he's going to get to eat the blancmange. Her high-spirited waving, his secret joy: the pain that stays with him.

Hermann's fifth memory flickers in my mind's eye like a sequence of images repeated again and again, in pale colors, as if they're being projected onto a dirty-gray sheet of plastic: his grandmother is pushing the stroller that he's sitting in along a gravel track. Hurriedly and roughly, not bothering about the potholes, she just manages to avoid the big puddles. Three or four women suddenly appear at the side of the road, out of the hollow where the grounds of the camp extend. Crying, they run over to the stroller,

embrace his grandmother and press his face to their wet cheeks. Then they run off, back into the grounds and his grandmother follows them; they come back, wrap their arms around him. They yell or groan something that Hermann cannot understand or refuses to understand.

"That was the first time I had some intimation of what had happened."

Two days later his mother is buried in Kleinmünchen Cemetery.

"But I refused to accept it," Hermann says.

WE KNOW hardly anything about her childhood apart from: addresses, school grades, photograph captions. It's too late to find out anything more since Gisela's sister died in 2007, a few months after her husband Franz Ripota, both could have told me some things. Her brothers Andreas and Albert have already been dead for nine or thirteen years respectively; Andi was the eldest of the Taurer children, he was born in 1913, Albert one year later, Gisela in 1917, Leni in 1919.

Gisela was eight when the family moved from St. Leonhard, a village on the northern outskirts of Villach, into the town itself, no. 7a Marxgasse. In 1924 she went to

the elementary school in Vassach, from 1925 to 1928 the girls' elementary school in Villach, from 1928 to 1932 the junior high school in Villach, following that the three-year course at the women's college for professions in business and industry. Her diploma has 'very good' in nineteen subjects, 'good' in five, she was given a 'satisfactory' in one alone: Foreign Languages (French I assume). Her parents, it says in a brief, strangely dispassionate biographical outline that someone in her immediate family must have written years ago, brought her up in the spirit of socialism. Even as a child Gisela had been "politically relatively aggressive, more than her brothers and sister." Pretty soon, it goes on, she had "come into contact" with Josef 'Pepe' Tschofenig, who was four years older—a friendship, quickly developing into love that clearly didn't need to look far, resting as it did on residential proximity, a common social background and agreement in outlook: they were railroaders' children, lived almost next door to each other for a while in Marxgasse (Pepe at no. 3), spent their free time in socialist youth groups, first the *Kinderfreunde* then the *Rote Falken*, ran around in the countryside, exerted themselves swimming, racing, skiing, honed their knowledge of the world and the way it ought to be at lectures and in discus-

sion groups. The older they became, the less the difference in age mattered; Gisela made up for Pepe's advantage in direct experience through the stimulus she received from home. A photo from 1932 shows her together with her family: five people in upright posture, facing the camera, their expressions proud and self-assured (only her mother is looking to one side); it is hard to imagine that anything could shake their confidence. In the album their names are listed along with their age and occupations; it sounds as if that's not for the family, as an aid to memory or a sentimental look back at the past, but for later generations: "The Taurer family in the 'music chamber' of 7a Marxgasse: Karl (43), Austrian Railways engineer, and Helene (40), housewife; Andreas (19), technical college graduate, and Albert (18), attending trade school, Gisela (15), girls' junior high school graduate, and Helene (13) attending junior high school." On another photo from thirty-two, taken at the Völkendorf Rote Falken group's holiday camp on the Wöllanernock, Gisela can be seen in a blouse and neckerchief with, behind her, the Red Office, a wooden hut with two open windows for 'Cooperative Shop' and 'Lost Property'. Longish face, straight, chin-length hair, arms hidden behind her slim body, right leg slightly bent at the

knee. A hint of skepticism or impatience in her look. And then, thirdly, the picture in which she's posing together with Pepe, in the snow with skis fixed, on this one she's smiling, her flat cap pulled down coquettishly over her right ear. In the short, tight-fitting jacket with the broad lapels, which emphasizes her figure, Gisela looks almost grown-up, at the same time light-hearted, carefree, as if time were on her side, with Pepe and their happy life together to look forward to. He's a good head taller than Gisela, six foot, perhaps even six foot two, and is looking straight at the camera. A lean figure, controlled strength, a dark, sunburnt face. One of the few photos on which he seems to be smiling: "Gailtal 1933: on the Oisternig (6676 ft.) in the Carnic Alps."

The previous year Pepe had already transferred from the Socialist Workers' Youth to the Communist Youth Association and it is clear that Gisela made the same decision, for in the biographical sketch it says that it was when distributing leaflets that the two of them "came into conflict with the police for the first time" (in Villach, presumably after the prohibition of the Austrian Communist Party in May thirty-three). It is pointless to ask who persuaded whom to switch from the Social Democratic

to the Communist Party—even without each other, they would probably, out of longing and insight, have come to the same conclusion; in any case it is difficult to see Gisela taking the step out of a sense of duty or submissiveness to her friend. Even if she did, then it is more likely to have come about the way Hermann thinks it did, namely that his Uncle Andi carried Pepe, who was the same age, along with him politically; that is also suggested by what the historian August Walzl says in his 1944 book *Gegen den Nationalsozialismus. Widerstand gegen die NS-Herrschaft in Kärnten, Slovenien und Friaul* (Against National Socialism: Resistance to Nazi Rule in Carinthia, Slovenia and Friuli), that in Villach it was above all Josef Tschofenig, Gisela Taurer and her brother Andreas who had tried to build up a group of the Communist Youth Association. In any case, the Taurer family very early on felt a sense of belonging to the Austrian Communist Party which is why they immediately made contact with communist circles when Karl Taurer, under suspicion of being politically unreliable was transferred from Villach to Linz, so that the family moved there in 1935—at first to 1 Memhardstrasse, then after May 1936 to 30 Untergaumberg, in the municipality of Leonding. It is not known what occupation Gisela

had in the first year after she finished school, whether she found work straight away. She missed her beloved mountains of Carinthia, it says in the biographical note.

SOME LIGHT—or perhaps a shadow—is cast on Pepe's circumstances by the official documents, of which there are copies in the Archive of Austrian Resistance: born on September 3, 1913, in Pontafel (today Pontebba, Udine Province) as the son of a railroad worker. Three brothers and one sister: Albin, Franz, Hans and Hilde. After high school he attended a technical college for mechanical engineering, was a trainee metalworker for a short time, then in the State Labor Service as an unskilled construction worker (wages two schillings a day). According to a certificate of July 4, 1953, from the Villach police, between October 1932 and February 1937 Josef Tschofenig was 'taken into police custody here' eight times for, among other things, lying under oath, causing malicious damage and communist activity. He was also twice detained in the prison of the Klagenfurt district court for the crime of high treason and presumed participation in the February uprising of 1934. On the advice of the Villach police, on April 12, 1934, the Director of

Security for the State of Carinthia issued an instruction that "in order to prevent disturbances of public order, tranquillity and security" Tschofenig was to be detained in Wöllersdorf internment camp from July 14, 1934, to September 1, 1935. "The person in question is well-known as a radical member of the Communist Party and, despite the current ban, was the 'political head' of the Communist Party in Villach and the surrounding area."

In July 1935 Pepe was released early after he had, "of his own free will," made a written declaration, "that after my release from custody I will refrain from any activity hostile to the state on behalf of a party forbidden in Austria, in particular the Social Democratic or Communist Party, and will strictly and loyally observe the laws and regulations in force in Austria" (*observe* instead of *obey*: a slip of the pen or an ironic play on words, unfortunately of no practical effect). At the end of February 1937 Pepe was once again to be locked up in Wöllersdorf, as ever "in order to prevent disturbances of the public order, tranquillity and security" and because "on the basis of the testimony of reliable informants and of his journey to and his time spent in the Czechoslovak Republic, about the purpose of which he refuses to give any information, as

well as of his well-known radical political attitude to the Communist Party, which is banned from any activity in Austria, he is to be deemed one of those persons who willfully promote endeavors hostile to the state and the government." But he clearly disappeared in order to escape imprisonment, for in a short biography written between 1951 and 1955, which can be consulted in the Central Archives of the Austrian Communist Party, it says that Tschofenig went underground in 1937 in order to avoid a lengthy period in Wöllersdorf. He was, it goes on, then active in the Spain Task Force and as an instructor in the provincial commission for the Western federal states.

The Spain Task Force—that means the transport organization that supported Austrian Volunteers in their efforts to get to Spain clandestinely in order to fight for the Republic in the civil war. There was a need for people to assist them in Tyrol and Vorarlberg, for concealed contact points for them to report to in Switzerland, and for the money to allow the volunteers to travel on by train, at least to Paris, where they were looked after by a committee and sent on to the Spanish border. In the middle of March thirty-seven the Austrian police managed to break up the illegal office of the transport organization,

though that only interrupted its activity for two months. Pepe was not one of those caught up in the wave of arrests.

It is not that easy to associate the photo from 1933, the one of the ski outing on the Oisternig, with the images that arise when looking through the confirmations of arrest, court decisions and official notifications. Or when imagining Pepe's life on the run, with forged papers. Years of keeping to the strict rules of life underground, the tension at every check, the presence of mind necessary not to give oneself away with an abrupt movement, an evasive answer. The weight of responsibility, the accelerated maturity of a man just over twenty. The enforced renunciation of a permanent residence and regular work (or welfare, however little that was). The life of an itinerant preacher of the resistance, staying with comrades in Bludenz, Wörgl, Bischofshofen etc, but also in small, out-of-the-way towns with no factories or railway lines, where he is recognized as a stranger and looked upon with a suspicious eye, unable to stay more than one or at most two nights, giving talks in forest clearings or mountain huts, on lake shores, in dimly lit kitchens, workshops, back rooms, handing out instructions in the name of the Party, defending decisions that possibly don't

always make sense to him, distributing illegal pamphlets. Control, self-control and discipline.

In contrast to that, his smile in the skiing photo with Gisela.

Of course the two of them found ways and means of seeing each other at irregular intervals, even after the Taurer family had moved, and there is no record of any prison sentence for the whole of 1936; it's possible that on his journeys to Czechoslovakia, to see the Party leadership in exile, Pepe sometimes passed through Linz, where they spent a few hours or a whole day together. Pfennigberg, Lichtenberg, Pöstlingberg, Gisela would indicate the local mountains, which were no mountains, just hills, *hillocks*, she said, perhaps tenderly stroking the hair off of his forehead with her other hand as he looked along her outstretched arm.

WITHOUT THE EXTENDED Gröblinger family, the memory of Gisela would have long since faded away. A dynasty of red rebels, the founder of which was a strike leader in the Great Dispute of 1911 in the Linz shipyard, for which he was fired by the management. How Alois Gröblinger managed to provide for his family during the

next few years is unknown, perhaps there was a locksmith or heating engineer who took him on despite the warning that this Gröblinger was a dangerous agitator and rabble-rouser. It's also possible that he was dependent on casual work for the rest of his life. In August 1914, shortly after the outbreak of war, Gröblinger was drafted into the army and sent to the east where, two or three months later, he is said to have fallen in or near Przemysl. He left a wife called Rosalia and six children: Alois, Mitzi, Resi, Rosi, Fritz and Greti. When he died, the eldest was just six, the youngest ten months old and although this did nothing to alleviate the tragedy of his early death, it was a great comfort to his widow that he'd been able to see little Greti before his involuntary hero's death.

Rosalie Gröblinger saw to it that the children followed in their father's footsteps politically. They were convinced socialists, which meant that almost all of them, together with their partners, took part in the resistance campaign of the illegal Communist Party during the period of Austrian fascism in the mid-1930s. Fritz who, as a member of the Republican *Schutzbund*, had been arrested after the defeat of the February uprising, emigrated to the Soviet Union in September 1934, to Sverdlovsk, where he worked as a fitter.

From there he went to Spain in June thirty-seven, to fight against Franco's troops in the civil war. Wounded several times, he was sent to the Aragón front in spring thirty-eight as a tank driver. He was reported missing on March 12, 1938.

Greti wanted to get to Spain as well and that together with her friend Gisela. The two women were young, single and adventurous, without steady jobs moreover, and their idea was that as nursing auxiliaries in the International Medical Corps they would be doing something useful, pursuing their political ideals and seeing something of the world into the bargain. Presumably Pepe had expressed the wish to go to Spain as a volunteer, but was prevented by his Party superiors because they still needed him for their illegal work in Austria. He could, of course, have ignored the Party instructions but he was too disciplined for that.

What is not known is why Greti and Gisela didn't make it to Spain. They certainly traveled from Linz to Lyons in April 1937 and worked there for a year as nursemaids with French families. It is said that after that they weren't allowed to cross the Spanish border. We do in fact know from reports by Swiss volunteers that women were already being refused entry six months after the outbreak of the

war, above all those who had no nursing diploma. It could be that was the reason the two of them had to turn back without having achieved their goal. Moreover by this time Austria had been annexed by the German Reich, so perhaps they felt the urge to return home to make themselves available for the campaign against the National Socialist regime. While soon after that Greti was drafted as a streetcar driver, Gisela took a position in the ticket office at Linz Central Station. There's a photo from the summer of thirty-eight, she's standing there on the station forecourt, still slim and smiling, in a dark dress beside an unknown colleague, on the left a streetcar of line B, on the right the station façade with the swastika flags; in a second photo from the same year she's holding the black kitten, Mungi, up in front of her face. As well as Greti, she was also a close friend of her sister Resi, married name Reindl, and of Anna Huber who had married Alois Gröblinger in 1938 and lived in the same neighborhood as the Taurers in Untergaumberg. Resi had a son called Herbert, Anna and Alois a daughter, Margit, who was born on New Year's Day 1937, married the journalist Franz Kain twenty-four years later and, after his death, made it her business to make Gisela's memory public. As a child she had been very fond of the

young woman, like an aunt who was particularly affection-
ate toward children. She remembers one Christmas Eve, it
must have been in Leni's apartment and during the war, in
1943; the tree had been decorated with wrapped-up pieces
of sugar, she recalls, and she'd pricked up her ears when,
late in the evening, her mother and Gisela had talked a
little mockingly about their absent husbands' moods.

But the first person to gather together material about
Gisela was the historian of the working class, Peter Kam-
merstätter. A metal worker, communist, prisoner in Buch-
enwald, Party official, he had early on made it his business
to compile collections of material on topics from the con-
temporary history of Upper Austria, in particular on the
antifascist resistance, and make them available to younger
researchers. In the eighties he had several interviews with
Resi Reindl, rambling dialogues through time and place,
with diverse ramifications, that kept coming back to Gise-
la's fate. Without these tapes we would only pick up her
story in scattered fragments, as one among many, that go
in one ear and out of the other.

PEPE HAD FLED to Prague immediately after the
German invasion. In the same year he settled in Ant-

werp, having been given the task of setting up a contact point of the Austrian Communist Party the purpose of which was to obtain material assistance for the many Austrian refugees in Belgium as well as organizing the transport of communist pamphlets and copies of the Party newspaper, *Die Rote Fahne* (The Red Flag) produced in Brussels, back to what used to be called Austria. For that, there were specially devised suitcases that Belgians took across the border, often making detours via Holland or Switzerland or even by ship, and handed over to contacts in Vienna. Another task was to collect money for the Spanish refugees who were living in France with no means of subsistence.

After the beginning of 1939 Pepe was assisted in his work by two men who had fought in Spain, Josef Meisel and Zalel Schwager. As Meisel recalls in his record of conversations published in 1985: *"Jetzt haben wir Ihnen, Meisel!" Kampf, Widerstand und Verfolgung des öster- reichischen Antifaschisten Josef Meisel* ("Now we've got you, Meisel!" The Struggle, Resistance and Persecution of the Austrian Antifascist Josef Meisel), the three of them shared a four-room apartment in the suburb of Berchem, "for us almost posh," and were supported by a Jewish com-

mittee with which Pepe was in close contact. "Although he wasn't a Jew, he was accepted by that committee, and could get a lot out of it. Through the Jewish sports club JASK, *Joodse Arbeiders Sportklub*, we were able to organize legal events in order to give Jewish refugees particular things they could do. We did a lot of political instruction. There were groups that sympathized with us and for them we did systematic instruction. Above all we went through Stalin's *Short Course*, which at that time was more or less obligatory as a basis for instruction. We also organized public events, I spoke at some of them."

Nothing is known about the circumstances surrounding Gisela's visit to Belgium. Both variants are imaginable—crossing the border legally on some harmless pretext as well as an illegal crossing with the help of a guide who knew the area and met her in a restaurant in Aachen. Continuing on to Monschau in the afternoon. In Kalterherberg, right at the foot of the hills of the Hohes Venn, he would have sent her on her way alone, in the twilight. On the other side of the border Pepe would have been waiting for her, at the station in Eupen. That was in July 1939, one month before the German-Soviet non-aggression pact that surprised the Austrian com-

munists as much as their Belgian comrades. "We very quickly," said Meisel, "came to terms with the situation. The Soviet Union will know what it's doing, the purpose is to thwart the plans of the Western imperialists, who are pushing Hitler toward confrontation with the Soviet Union. These arguments helped us to con ourselves into thinking the Soviet policy was right."

Antwerp was a prosperous town. The Austrian writer Hans Mayer, alias Jean Amery, who had found refuge there six months before Gisela, had been surprised at its "obvious wealth." Perhaps Gisela had also expected to be faced with "somewhere wet and gloomy, with taciturn people going about their business among domed fortresses and dockside sheds" and had difficulty associating the throbbing life on the Meir and the Keyserlei with this image, above all on summer evenings when people were sitting in the street cafés eating ices or warm waffles and chatting animatedly in Flemish, a minor disappointment for Gisela, who had assumed, thanks to the French she had acquired in Lyons, she would be able to follow the conversations at adjoining tables with ease. The high standard of living, the peaceful atmosphere, the opportunity, thanks to the support of

Jewish organizations, to live cheaply—"We were able," as Meisel says, "to make full use of that and almost felt as if we were in paradise." This sense of unalloyed happiness may have been particularly the case for Gisela and Pepe, after all in Antwerp it was the first (and only) time they were able to live together as man and wife, lacking only a marriage certificate, and since their presence in Belgium was accepted by the authorities, they weren't forced to avoid being seen in public. As well as Gisela's identity card, valid until the end of 1940, and her ration card issued on February 8, 1940, there is also a photo extant, in which the two of them are strolling along one of Antwerp's shopping streets on March 31 of that year, in fine winter coats, Gisela with a jaunty little hat, Pepe wearing a white collar and tie; at that point they were unaware of their new happiness, Gisela's pregnancy.

The German invasion of Belgium caught them unprepared, although three or four days beforehand instructions had come from Moscow for senior Party officials to go underground. "We didn't get around to doing that," Meisel said, "we didn't take it that seriously." In the very night of the invasion he and Pepe were taken from their beds by Belgian police and driven to the station. There

they had to wait, together with other refugees, for a long special train to be put together. It's difficult to say why Gisela wasn't arrested as well. Perhaps her political activities had gone unnoticed, or women were as a rule exempt from deportation, or she had in fact done nothing at all to attract the attention of the authorities. According to Meisel it had earlier been agreed, again following instructions from Moscow, that any partners who were not directly threatened should return to Austria in order to do political work there. The agreement between Hitler and Stalin led them to believe that any who went back would have nothing to fear for the time being. According to Meisel, Gisela Taurer was among the comrades to whom this applied. "Together with Tschofenig and other Austrian comrades in Antwerp, I was part of a convoy of about 2000 Jews, mainly orthodox former Polish Jews with long beards. I mention that because attempts were made to use us on the journey to the south of France to stimulate a bellicose mood among the Belgian and French population. They wrote *parachutistes* on the cars. And the paradoxical thing about it was that we were bombarded with stones, even though old, bearded Jews were looking out of the windows."

The journey ended in Saint-Cyprien camp, right on the Mediterranean, quite close to the Spanish border. Pepe doesn't appear in Meisel's memories after that; but notes written from memory by their comrade Gerhard-Paul Herrnstadt in 1965 tell us that Pepe managed to escape from Saint-Cyprien and, together with him, Meisel and other Austrian communists hid in a mill near Dufourt in the department of Haute-Garonne until the autumn of 1940. One possibility is that he decided to return to the Reich and was arrested by German military police at the demarcation line between the occupied zone and the free zone of France. However it happened, not much later he was in the custody of the Klagenfurt Gestapo, for in a letter of November 25, 1940, from the Secret State Police, State Police Office Klagenfurt, "Fräulein Gisela Taurer," of Linz-Upper Danube, was informed, in reply to her letter of the 19th of that month, "that for reasons of state security the release of Tschofenig during the war is out of the question."

Gisela's return journey from Antwerp is almost completely substantiated by six documents—her application for a laissez-passer, the issuing of one by the German Army Garrison HQ 675, her request for support from the

Belgian section of the NSDAP Women's Organization, permission to use military vehicles granted by the Brussels military police, permission to continue her journey granted by the Aachen-Cologne NS Women's Organization, and entitlement to travel by rail from the German Army Transport Manager's Office in Brussels. She arrived in Linz on June 13, 1940. She was three months pregnant and there is no record of any official action against her. In the afore-mentioned biographical sketch there is a brief excerpt from her diary, which has been lost.

At the end of July I felt the baby's first movements... On December 19 Mother and I went to our new apartment (Füchselstrasse): no light, no heating, ice-cold. I slept together with Mother, wrapped up to the tip of my nose. In the morning I could feel pains in my lower abdomen. In the evening before midnight Mother went to fetch the midwife. They only arrived at 12:15. The contractions were already very strong, but I didn't want to cry out loud as Father and Andi were asleep in the other room and had no idea what was happening... The midwife calmed me down with the confident way she went about it. The circumstances were any-

thing but normal: the beds had been pulled apart, no
light, Mother had to stand at the foot with a candle...
At 1 a.m. the baby emerged with a cry. When the mid-
wife said, it's a boy, I looked down: my son was lying
there, small but full of life—I lay back, happy and
contented...

In that same month, December nineteen-forty, Pepe
was transferred from Karlau Detention Center near Graz
to Dachau Concentration Camp where, as foreman of the
X-ray department, he gained the reputation of a brave,
selfless, incorruptible *Kapo*—a prisoner with supervisory
duties. Ferdinand Hackl from Vienna, who had fought in
Spain and was sent to Dachau six months later, remem-
bers two meetings with Pepe. The first was after Hackl
had got someone to give him a fever-inducing injection
in the Kottern satellite camp. Being ill, he managed to get
himself transferred to the main camp, where he intended
to report irregularities in the satellite camp to the ille-
gal prisoners' organization. When Pepe learnt that the
fever had been artificially induced, he accused Hackl of
self-mutilation. The second memory concerns a meeting
a few weeks before the liberation, when Pepe was in the

sickbay with typhus fever and, despite his weak condition, greeted Hackl, who wanted to encourage him, with a clenched fist. Fritz Zahradka, another Viennese who had fought in Spain, also worked in the X-ray department. According to his widow, the friendship between Pepe and Fritz, which had started there, lasted until he died. "I would describe Tschof," Gretl Zahradka said, "as this kind of man: if there's a piece of bread lying there and he's hungry, he wouldn't touch the bread."

AND WHAT IF she'd done nothing at all. If between Hermann's birth and her wedding three and a half years later nothing worth mentioning had actually happened, as is suggested by the chronological table in the biographical sketch that only notes three longish visits for Gisela and Hermann to Villach, Bischofshofen and Selztal, the first to stay with Pepe's mother from May to September forty-two, the two others, in August and September forty-three and in March forty-four with Gisela's brother Albert who, as traffic superintendent for the Reich railroad, led a nomadic life.

Little is known in detail about her underground activity, on the one hand because Gisela was never taken

to court and there is therefore no indictment listing her actual or presumed illegal actions, on the other because none of the men with whom she worked survived the Nazi period. At the end of April forty-five, one week before the liberation of the concentration camp, they were murdered on the order of Gauleiter Eigruber in Mauthausen. For example the fitter Sepp Teufl, head of the Austrian Communist Party since 1933, for whom Gisela typed leaflet appeals or articles for an illegal Party newspaper and is also said to have worked as a courier. Through that she was in contact with the welder Franz Haselmeier, who must have given away her identity under torture. At least later on, in Kaplanhof Women's Prison, she told her friend Resi Reindl that during an interrogation she was suddenly confronted with Haselmeier, who begged her to admit everything, telling her that the Gestapo had already been informed about her activities anyway.

Greti Gröblinger was the first of her women friends to be arrested by the Gestapo. Together they had made contact with Frenchmen working as forced labor in the Hermann Goering Works. At that time Greti was married to Alfred Müller, a colleague from the transport services who, as a soldier in the Wehrmacht, was reported miss-

ing after the Battle of Stalingrad. In February 1942 she took up a post as an engineering draftswoman in the Linz board of works. It was there in 1943 that she was reported by a colleague for "remarks detrimental to the state that reveal her communist attitude," arrested, tried in a police court and sentenced to four years in prison. When Gisela was then arrested, Greti was already doing hard labor in the Kolbermoor munition store near Rosenheim.

Before all this, however, Gisela had been given permission to marry Pepe in the register office of Dachau Concentration Camp, which was otherwise only used to register deaths. Presumably she had made several requests about this since Hermann was born until, on May 5, 1944, she was eventually informed by the registrar that all the necessary documents had arrived. "Your bridegroom has set June 3, 1944, as the date for the marriage ceremony. You are therefore requested to attend at the Dachau II register office at 8 a.m. that day. On showing this letter at the main guardhouse of the Camp you will be given a visitor's pass and taken to the register office. Two witnesses are required. Should you not be in a position to obtain any, I will see to it."

It may seem strange that the wedding in the concen-

tration camp was sanctioned. It is a fact, though, that Gisela's request was in line with the National Socialist family policy of legalizing intimate relationships wherever possible—one purpose of the wedding was to give Hermann the status of a legitimate child (and, indeed, Gisela was informed as early as July 6 by the Linz/Donau district court that this had been agreed). Of the ceremony itself nothing has come down to us except one wedding photo. It is known that Karl Taurer and Theresia Tschofenig accompanied Gisela to Dachau as witnesses. Also accompanying them was Pepe's sister Hilde, a girl of eleven or thirteen at the time, today an old woman who absolutely refuses to release her memories of the event or any of those of her brother and sister-in-law. "Who's interested in that nowadays," she says over the phone, repeats the sentence without waiting for an answer, mentions the lack of discipline of present-day youth, also the fact that the memorial plaque for the victims of Nazi terror in Villach, where she lives, has repeatedly been smeared or smashed, then says twice in quick succession, "Not interested. Thank you," and hangs up.

At least there's the photo from Dachau, of Gisela, still as slender as she was as a girl and with a slightly embar-

rassed smile, and Pepe with a skeptical expression on his face. She in a white blouse under her dark jacket, he with short cropped hair, suit and tie from the SS store of prisoners' civilian clothes. Near the bottom of the picture: Gisela's slim hand, diagonally across it a posy of white carnations. What is surprising is the warm tone of the letter from the registrar, who sent Gisela that and other, no longer traceable photos ten days after the wedding, "Dear Frau Tschofenig, Enclosed I am sending you the wedding pictures, I trust they will give you much pleasure. The photos have turned out really nicely. I hope the time will soon come when your happiness is complete. That is the wish of the Registrar. With kindest regards,…"

The signature is illegible, as it is on the other documents from the registrar. His identity was only revealed to me by Albert Knoll, the archivist at the Dachau Memorial Museum, after he'd asked his colleague, Andreas Bräunling of the Dachau Town Archives: the man was called Hans Mursch, was an SS Oberscharführer, head of the camp's own registry office from May forty-one and enjoyed an excellent reputation among prisoners; one of them, Reimund Schnabel, described him in his 1966 report *Die Frommen in der Hölle. Geistliche in Dachau* (The Devout in Hell. Priests in

Dachau), as "very soft." Mursch, he said, once refused to beat a prisoner and as a result was transferred to the clothes store in punishment, where he had a friendly, encouraging word for every new inmate. "At the arrival of a convoy of particularly run-down, starving and ragged gypsies from Hungary in 1944 Mursch wept tears of shame and shock out there on the country road and was arrested by his superiors. Since, however, they were afraid he might know too much about their black-market dealings, Mursch got away with close arrest and disciplinary transfer to a subordinate position, where he no longer came into contact with prisoners. It was matter of course that after the liberation this man was publicly rehabilitated by the prisoners."

IMMEDIATELY after her return from Dachau, Gisela had written a letter to the Central Security Department of the Reich in Berlin requesting "the release of my husband Josef Tschofenig, b. 3.9.13, prisoner no. 22,139— Dachau K3 Concentration Camp," and in the reasons she gives, she manages to adopt the way of thinking of the National Socialist authorities: "During his four years in prison my husband has certainly shown himself worthy of this kindness through his good behavior in the camp

and honest execution of the tasks assigned to him. It would be very desirable to establish a family after the wedding in Dachau, also my husband has not seen his son since he was born, as he was sent to the concentration camp before that. Establishing a family would mean that the number of children would rise from year to year, because my husband and I are particularly fond of children. I therefore most sincerely beg you to accede to this request and give back her husband to a woman who has a great love of children and wants to fulfill the duty of a German woman. In anticipation of a favorable outcome, I conclude my letter with Heil Hitler!" A letter of rejection from Berlin cannot be found, perhaps Gisela's arrest meant it was no longer necessary.

Resi was also meant to be arrested in September forty-four. Two men from the Gestapo were already in her kitchen, when suddenly there was an air-raid warning, at which the Gestapo dashed off to get to the safety of an air-raid shelter. They didn't come back to fetch Resi until two weeks later. While she was worried about her husband Karl, who was the only one of Sepp Teufl's resistance group still at liberty, she was cautiously confident as far as her own fate was concerned. She knew that her contact, Max

Grüll, hadn't revealed her activity before he died under torture, otherwise the Gestapo would have taken her with them the first time they came. While she was in Kaplanhof Women's Prison, she ran into Gisela in a trench during an air-raid and her friend, who by then had been interrogated in Mauthausen, told her about the conditions there: the equipment in the interrogation room, the cruel tricks of the Gestapo officers and the differences between them. She warned Resi to make sure she always kept her back to the wall. She herself, she said, had received such a violent blow, she'd been flung right across the room and straight into the waste-paper bin. The confrontation with Haselmeier, his insistence she come out with what she knew, not continue to remain silent: "They know everything already anyway." And then the worst of all, the casual remark of her torturer, "You'll not see your child ever again."

But in Gisela's messages to her mother, on postcards and in two letters that were smuggled out, the only fear she expressed was about her son Hermann's health, about the air-raids, during which the Taurers, living in the building right next to the railroad track, were in particular danger, about her brothers and sister, about Pepe in Dachau. Leni had had a son, Peter, in March forty-three and Gisela was

also concerned about whether the two boys, whom she once sketched from memory, got on well together. Hardly a word about the constant hunger, nothing about the plague of lice, the icy cold, the grim female guards who beat up the prisoners at the least excuse. Her last card from Cell 12, Kaplanhof, was written on March 28, 1945:

Dear Mother,

Today on little Peter's birthday a few words to all of you at home. What are the two little boys doing? I hope they're well and happy and that my little boy remembers me, Peterle won't remember me, will he? And it's Hermann's name day next Saturday—and Easter's almost here, just to be able to be with all of you, that's my only wish. Bring me a few photos of the two boys some time, won't you, it'd be a real joy for me.—Thanks for Albert's letter, he hasn't forgotten me, then, is he in Salzburg already? Andi will be bored in prison without his harmonica, but you'll be glad you've heard from him, won't you Mother. Thanks to Papa for his best wishes and tell him to stay healthy and not be worried about me, I'm well. Now we have this lovely spring weather I'm sure that, despite his

limited free time, Father will be proudly taking our two little ones for a walk, is that right? And you two, you and Leni, have the work and worries for all of us. Just good health and no 'blessings dropping from above' and we'll all hold out until the happy day when we're together again. If Leni has time to come, then as soon as possible, I urgently need a few things such as cotton wool, skin cream, bobby pins, combs, moreover I'd like to throw out my walking boots, please bring me some shoes and my black gym shorts, the last nightie you brought has had it, I'm throwing it out.—And now, my dears, I wish you a 'quiet' Easter, no dashing off to the air-raid shelter. My best wishes to you and all my loved ones, lots of kisses from his Mommy for my little Hermann. He's to do lots of drawings for me, little Peter as well.

THREE DAYS LATER American planes bombed the prison. In the late afternoon the dull throb of their engines coming closer and closer until it was right above them, then the release of the bombs, just as Resi, in Cell 10, was trying to reassure her fellow prisoners, "There's nothing to worry about as long as they haven't released

their bombs—" immediately followed by the whine, a crash, a hole in the ceiling with a patch of blue sky visible through it, a bed with little flames licking up, the burst pipe over the cell door with water pouring out, the outside wall collapsing into the cell and Resi shouting, "Quick, let's get out before we get burnt to death!" From her bed on the top bunk the women struggled out through the hole onto the roof of the hut, slid from there over a shutter down onto the ground. Dead and wounded women everywhere, flames and smoke, screams and shots, in the chaos Resi and Gisela managed to get together and run to a brick-built shed, where they thought they'd have more protection from the hail of bullets from the low-flying planes, then an SS officer, from Hungary or the Ukraine, was aiming his gun at them. Now he's going to shoot us, Resi thought, and closed her eyes.

A few days before this, Helene Taurer had received a letter from Dachau:

Hi, After months—at last—I got your postcard of the III/6, dear Mom-in-law. Now I can tell myself, at least that's something—for until now I was completely in the dark, no mail—& when something did come

from Villach there was never any news about Gisela in it. You write that I don't need to worry about Gisi, well, that's easily said, it's six months now & still nothing's settled, & I shouldn't feel concerned? Yes, I was delighted to hear that she's in good health; the parcels you've taken will do her good & are probably necessary. Actually everything's back to front with the two of us— at our age (I've already got lots of white hair!) we're still a burden on you!—I can imagine that our 'little one' is well looked after & you and your sprightly old man (how is he) are really spoiling him! What are the others doing, what's Andi up to—hope I'll soon hear more about Gisi from you.—From my scribble you can tell that I've been through something—but 'weeds keep on coming back,' and now everything, health included, is back to normal. So I'm looking forward to getting a reply soon and a more detailed letter. If it's possible give Gisi my heartfelt wishes.

Goodbye, dear Mother-in-law,
Best wishes from Pepe

THEN SOMEONE SHOUTED, "Don't shoot!" A policeman, who'd been detailed to guard the prisoners, climbed out of the trench where he'd gone for safety with the female guards, covered in blood but clearly not seriously injured, ran toward the SS officer and shouted again, "Don't shoot, they're not gong to run away." And Gisela and Resi hurried on, over to the trench, but suddenly there was a man there, on the canopy over the entrance out into the street, a good-looking young man, as Resi was to tell Peter Kammerstätter years later, a foreigner, presumably a forced laborer, perhaps even one of the French Gisela and Greti had been in contact with. "Come on," he said, "I'll help you up." And Resi said, "Please, Gisela, see that you get away, let him help you, get over the wall and then run!" Because, Resi was to say, those words Gisela had heard the Gestapo officer in Mauthausen say were still going round in her head: *you'll never see your child again, and that's for sure.*

"Look, Gisela, in my case there's nothing they can prove, otherwise I wouldn't still be here, but if he said that to you, then don't wait any longer. Get to safety. Run away. Go on, run!"

"I can't," Gisela said.

"Why ever not?"

"Because then they'll go and get my family, my parents, Leni, even Hermann."

THAT SAME EVENING the surviving women were herded on foot to Schörgenhub, to a half-finished hut in the grounds of the so-called work-education camp, which had been set up in spring forty-three for forced laborers who had escaped and been caught again, were refractory or otherwise accused of lacking in discipline. Now Resi and Gisela were in the same cell together with other Upper-Austrian women from the resistance—an old woman who had only been arrested because she was the mother of the communist official Franz Haider; a maid from the Mühlviertel who had been made pregnant by a farmer who then, because he wanted to avoid having to pay maintenance, had accused her of having had an affair with a Pole; a store-owner who had hung a white flag out of her window too soon; and recalcitrant female workers from Poland, Russia and the Baltic states. It was there in Schörgenhub that Gisela, on April 23 and 24, 1945, wrote her last letter, this time to her sister, illustrated by a self-portrait in which she's warmly wrapped up.

She had intended to give it to a woman who was released on the 25th, but was afraid she might have to submit to a body search first.

"If they find it, it'll be used as evidence against her. Will you please take it," she said to Resi. "Then if you get out you can take it to my mother."

"Of course," Resi said, slipping the letter up her sleeve. "You can rely on me."

Dear Lentschie,

Four letters all suddenly arrived at once, Hermann's drawings, Albert's letters, from Mother & from you. Well, you can imagine my joy at getting them. Now the days are dreary, rain & wind, cold—we spend almost the whole day just sitting on our beds, I've got everything on apart from my shoes—who knows what might happen any moment? Hermann would be astonished if he could see his Mommy!—I've got a little abscess on my tooth and have wrapped my scarf and a pair of white trousers around my head, I'm sitting on my bed bundled up in blankets, I keep on having a look out of the window in case one of you should come. So what does my little boy say to a

Mommy like that? But, hey, are you with the 'mucky little pup' in Linz? God I'd really love to be able to give the little fellow a real hug, how often do I dream of it, but something always gets in the way—but I'm not going to waste my time on dreams as a matter of principle, because reality suggests I'll be able to marvel at the two little ones soon. Resi told me how Peterle stuck one piece of garlic after another in his mouth like candy. Quite calmly and carefully, as is his way. And didn't make a face at all.—Oh, Leni, I just hope there's going to be a happy reunion. How often do you all go to have your photo taken, Peterle for his birthday with Mother? I often think it's incredible that Hermann can draw like that already, I can hardly believe the great progress he's making. But when I come, he must love me even though I come empty-handed—yes, here in Kaplanhof I'd been keeping an Easter present for him and Peterle, colorful Easter eggs with candy (that from Resi!). But since none of you came before the holidays, on that tragic Saturday it was blown up with everything else—pity. It seemed a miracle to us survivors that we're still alive. —Another day's over again, it's Tuesday already, I ought to remove my muzzle

now, because the pain's already wearing off, but it's so warm, so why not!—I spend so much time thinking of all of you at home, the way you live, hoping you're all well.—The stupid thing is that my track suit was burnt, because I'd just washed it. There were 15 of us in our cell, 8 were killed, 3 seriously injured, perhaps they're dead already, & only the 4 of us escaped unharmed. Resi's unharmed too. It was all so horrible I don't want to think about it anymore.—Where is Albert now? His letters are a sign that he's OK, unfortunately there's quite some time between them & you don't know what's happened in between. Oh well, & Andi as a carpenter, that's really funny, but I imagine he gets better food than we do here, for it's no exaggeration to say that it's often not fit for pigs, no salt, etc, etc, no matter, I just hope this state of things will soon be over. I often wonder now what things are like for Pepe & where he is. Does he write? And from Villach? You can put letters in the parcel as well, perhaps I'll get them. But you can put newspapers & other 'trashy novels' in, they do help to pass the time. Sewing things, my stockings and leg-warmers are full of holes!! Yes, when Mother was here with Hermann, I didn't recognize them at first, he was

so tall—God, if I don't get out of here soon, he'll really have shot up.—How's Father—at work & in his free time? I'm looking forward to a letter from him!! And you, Leni, you're lying in bed all day, 'seriously ill', just get locked up, you can lie in bed all day—then you'll get fed up with it. We've got a midwife here too, from Hohenfurt, delivering a baby's great fun when she's there!!—It's just occurred to me, tea in a bottle, if one of you should come. Boiled potatoes, otherwise what- ever you can manage—if only it wasn't such a long way out to this lousy dump! I'm giving you so much trouble, it often drives me hopping mad!

Pencil, writing paper, please.

PERHAPS THE FIRST to see it, three days later, was one of the women who went to fetch the drinking water in milk churns from the men's camp. Another who had just wiped the floor in the sickbay (a shack that didn't deserve that name). A third who, like Gisela, was was longingly keeping a lookout for her family through a crack between the planks nailed over the window. Or all of them together, when they came back from gathering stones on the Welser Heide. (No, the gathering of stones was earlier, gathering

and piling them up, now they weren't taken out of the camp during the day anymore.) Namely that a detail of prisoners, supervised by a man in uniform, was busy outside the sentry hut. But so late, that was unusual and aroused their suspicion. Therefore Gisela and Resi requested permission of the woman guard to be excused. The latrines for the women's camp were ten or twenty yards back, on a low rise. If you climbed up onto the toilet seat and stood on tiptoe, you had a view of the whole of the camp as far as the sentry post through the skylight. They saw that the prisoners were digging a pit. Then the men, shouldering their pickaxes and shovels, marched back through the barrier into the camp. But two shovels were left propped up against the wall of the hut.

On April 17, 1945, at four in the afternoon, perhaps one hour later.

On that same day the Provisional Government in Vienna had proclaimed the independence of Austria and an infantry regiment of the US 7th Army was advancing on Dachau from the west. But the women, returning to their bunk beds, didn't know that, and even if they had known, it would have been of no help to them.

"Why dig a pit, unless they intend to—"

It is not known whether those words were spoken. Usually the late afternoon was their favorite time of the day. Take off your shoes, climb up onto your bed, think about your loved ones, chat a little about things at home. But that day, according to Resi, there was a tense silence. Just two women whispering to each other, two or three sentences, a question, then falling silent.

"Something's going on. You can sense it."

Silence. Until footsteps could be heard outside, a male guard flung open the door, bellowed three names. "Line up! Take blankets! Follow me!"

Höllermann, Tschofenig and a third woman, whose name has not even survived, a Jew, said to come from Vienna, who had been brought in two days previously. Perhaps until then she had managed to remain in hiding somewhere and been picked up during a check in the street or an air-raid shelter. Risa Höllerman belonged to the so-called Wels group of the Communist Party, she had maintained the contact with their comrades in Vienna until she was arrested on September 8, 1944, in the Wels station restaurant. Risa was the first to get to the door. Gisela was squatting down, quite calmly, as it seemed, tying her walking boots.

"Get on with it, Gisela," Risa urged. "Hurry up, otherwise they'll beat us again. You know how nasty they are."

"Don't rush me," Gisela said. "I need my boots. Who knows, we might have to run."

Finally she stood up.

"Right, that's it," she said quietly, giving Resi's hand a squeeze as the guard came back.

Sleep was out of the question. One of the remaining women walked up and down the cell, restless like a caged animal, the others strained to hear what was happening out in the twilight. "Well, and suddenly we heard shots," Resi's voice says on Kammerstätter's tape. "Every one went right through you: For God's sake, what's going on out there. It's an execution. And again. Then they run past. Then they run past again. Six times it went on like that."

The woman who couldn't bear to stay sitting on her bed had been peeping through a crack. Then she went over to Resi and whispered, "After every shot they carry something past in a blanket."

"But they won't have the bodies in them," Resi replied. "Probably an item of clothing or something."

"Yes," the other woman said, "it's as if they're carrying a bundle."

That was the first night without Gisela. The next morning Resi saw one of the woman guards wearing her friend's boots. Then she knew there was no hope left. The camp emptied. The last women, there were still twenty of them, were released on the third of May. Before that the guards had made off in a truck. Resi took old Mother Haider and the pregnant maid from the Mühlviertel with her to her mother-in-law, who lived in a little house in the Neue Heimat development in Linz. Herbert, her son, was there as well.

Two days later units of the Third Army arrived in Linz. At first there was just the fear, then the certainty that her husband Karl had been murdered in the gas chamber of Mauthausen on April 28 together with Teufl, Haselmeier and forty other comrades from Upper Austria. Risa Höllermann's husband had already been shot by the SS on September 18, 1944. Greti only arrived back home in the middle of June. Because she had been working in an armaments factory, the American authorities had delayed her return for a long time. In court she exonerated her colleague in the Board of Works who had informed on her. She said the woman hadn't been aware of the consequences of her action. And she, Greti,

had experienced what it meant to be locked up and she wouldn't wish that on anyone, even her worst enemy. There was no real feeling of joy at the end of Nazi rule. The women threw themselves into Party work, reconstruction, the daily struggle for food. But the people around them seemed incorrigible. And the dead remained dead. They felt, as one of their comrades, the worker-poet Henriette Haill, said, as if a gray pall of misery had descended over them.

They arranged to meet in Schörgenhub on the thirteenth of May. Karl Taurer procured a cart and a few shovels, and engaged three or four colleagues from the railroad, until recently fanatical Nazis, to accompany him. Resi was there before them. Also Karl Kastner, the husband of her sister Mitzi. Beside the sentry box they found a barrette that had belonged to Gisela. Four meters away the ground had been recently disturbed. That is where the group or prisoners had had to dig the pit on the twenty-seventh of April. One of the railroaders, a strong, tall, young man, was sick when they came upon the first corpse. On top were three men, the women underneath them. Gisela was the last, which meant she was the first to have been shot. She was the only one lying on her side,

her left leg over the right one of the woman above her, as if frozen during violent movement, she'd probably still been alive when the pit was filled in.

They put the bodies on the cart and buried them in Kleinmünchen Cemetery. It was decades before the identity of the men who'd been shot was known. After a report in *Stimme der Frau*, a reader from Floridsdorf, a certain Michael Rackwetz, had written, "Dear Editor, I read the article about Gisela Tschofenig in your paper. I was deeply moved by it, not just in the way all decent people would be bound to be moved, but even more so, since in my family I also have victims among my nearest and dearest. My brother and my nephew were executed at the same time as Gisela Tschofenig. It says in your article that three unknown men were executed on the same day as Gisela Tschofenig. It is possible that my brother, Theodor Rackwetz and my nephew, Thedi Rackwetz, listed by the Gestapo with the first name of Rainer, were among them. All we know is that they perished in Mauthausen, but not precisely when or under what circumstances. I would therefore very much like to ask you to publish the pictures of my brother and my nephew, perhaps someone who was in Mauthausen will recognize them and can give us more

details of their death. Many thanks in anticipation."

But father and son Rackwetz were in fact murdered in Mauthausen itself and that on October 15 and 16, 1944. The three men in Schörgenhub, who were shot shortly after Gisela, Risa Höllermann and the unknown Jewish woman, were called Leopold Hessenberger, Heinrich Stadler and Franz Popp. Stadler and Hessenberger came from Gmunden; one of them, a bandmaster, had been arrested together with his wife and other musicians for anti-Nazi comments, the other for communist activities. Popp, a farmer from Molln, had been accused of listening to enemy radio stations and having invited a Polish forced laborer to join him. The Pole was murdered in Schörgenhub as well, on the sixth of April, and Popp's wife at the beginning of May in Mauthausen, by drunk SS officers, it is said.

Then there are three pages full of upright handwriting that Gisela's mother had torn out of a lined school exercise book, in which Hermann had drawn steam locomotives and trucks:

Hermann, your mommy was arrested on September 25, 1944. Hermann, Leni and I knew why, it was

terrible. Your mother in the Gestapo hell. It was our wish to have you. And on April 27, 1945, at 8 o'clock in the evening, your mommy was shot by the SS camp commandant and the Hungarian sentries. Aunt Resi heard everything, there were two other women and three men. Hermann, on May 13 we, that is Aunt Resi, Kastner and I, shoveled the rubble on the mound away and we came to the bodies. Hermann, we were glad that we got the bodies, your mommy. That we knew they were asleep. Hermann, now we'll go and search for Leni and Peter, search until we find them. Hermann, your mommy was buried on May 15, 1945. You were there, you know, with the dead woman and her little boy, she had a lovely room with lots and lots of flowers, electric light with lots and lots of bulbs. She was buried without Leni, without Peter, without Albert and Andi, but you were there, you threw some beautiful daisies in for her. Hermann, I don't think I can see Albert and Leni again, I think my heart's going to break. Hermann, what will you do then. Peter, Leni, Albert, Andi, Grandmother, no one there.

They were all there, soon after. Leni and Peter were

the first to return; they had gone out to a village, to Leni's mother-in-law, because of the air-raids. Then Albert appeared at the door. Because he'd been recruited at the last moment by the SS, he had simulated mental illness and was in a mental hospital when the war ended. Finally Andi and Leni's husband Franz were released from the prisoner-of-war camp. Now the family was complete again. Only Gisela was missing. Casting a shadow over the family that Hermann didn't notice at first. And that is his sixth memory, being picked up out of bed, at night, by a total stranger and pressed to him, so firmly he can't breathe. The rough material of his jacket, the scratchy stubble of the stranger, who is his father, frighten him.

He doesn't understand what the grown-ups are talking about. No one tells him that his time with Gisela's parents is limited. His grandmother and Aunt Leni fulfill his every feasible wish before he's even mentioned it. Andi plays his accordion for him. Albert makes him a toy railroad with rails, switches, barriers, signals, station buildings and switch towers, all out of pearwood, for wheels his uncle used empty cotton reels.

In the summer of forty-six his father comes to fetch him. He's accompanied by a woman. Their relationship

is not mentioned in Hermann's presence, and he doesn't want to know anyway. Only two years later does he begin to suspect what it's all about.

IMMEDIATELY after his return from Dachau, Pepe had been elected chairman of the Carinthian Communist Party and was sent to join the Provisional Government with responsibility for internal security. After the elections in November forty-five, in which the Communists did considerably better in Carinthia, with eight per cent, than overall in Austria, he was a member of the provincial parliament until 1949. As well as that, after the thirteenth Party Convention in February he was a member of the Central Committee. The difficult situation with the supply of food and other essentials, the constant conflict with the British military authorities, the territorial demands of Yugoslavia, with its counterpart the constant hate campaign against the Slovenian minority, the unresolved problem of displaced persons, strikes and dismissals in factories, the half-hearted denazification process that very quickly had obstacles put in its way—all that took up his time and energy. After his many official duties during the day, he would bury

himself in files, complaints, situation reports until deep into the night. Perhaps this unremitting activity suited him, in that way it was easier to bear the phantom sorrow in the emptiness of his heart, that was presumably eventually filled. Whatever the case, Magda Fertin was soon at his side.

Hermann thinks that the two of them became closer through working together. In Klagenfurt, in the Party offices where Magda worked as an official. A young woman who of necessity remains faceless for me, almost bodiless as well, she was powerfully built (but not fat), Hermann says, a bit chubby according to his friend Hans West, who was later on to live, with his parents, next door to the Tschofenig family in Vienna. Although during her working life she was employed solely by the Party or by a firm belonging to the Party, there is no material on Magda in the Party archives. Not a trace of her in the various papers on the operations of the Slovenian partisans in which she was involved. Only in the Documentary Archive of Austrian Resistance is there a statement by Pepe from 1966, taken down by Tilly Spiegel, according to which Magda had been a member of the Communist youth organization since 1938 and after 1943 in

Klagenfurt had liaised with the partisans operating in the Rosental, to the north of the Drau. At the beginning of October forty-four she had been arrested, he said, and sent to the provincial court in Klagenfurt but, with the help of some police officers and friends had been able to escape to Köstenberg by Velden, where the partisans had a base. After going into action several times to the south of the River Drau, she entered Klagenfurt with her unit at the beginning of May forty-five. Dispersed troops of the so-called Vlasov Army, which had fought on the side of Hitler, had made a continuation of the war necessary until the beginning of June, he explained.

Were her parents still alive. Did she have brothers and sisters. Did she like going dancing or to the cinema. Was she sociable. Hermann can't remember. She had relations in Norway, he says. And once she talked about 1938. She'd been to a convent school, she said. (Probably with the Ursulines, though no class registers from the time before forty-five have been preserved and there's no Magda on the lists of boarders.) When the German army invaded the country, she went on, the classes had been let out early so that they could cheer the soldiers. All the passers-by were full of enthusiasm. Only one old

man had turned aside, muttering as he left, Hitler brings misfortune. Soon we'll be at war.

Hermann went to the first two elementary school classes in Villach, where he lived with Pepe's mother, once more in a railroad worker's apartment that was cramped but didn't feel like that. His Aunt Hilde, who was still at high school then or had just started an apprenticeship as a salesperson, helped him with his homework. Hermann felt safe and secure with Granny Tschofenig, whose husband had died before the war. Even later he often went to stay with her. But, "I would love to have grown up in Linz."

In 1948, six months after his half-sister was born, Pepe and Magda took him to live with them in Klagenfurt. They'd named their daughter after his mother and it was as if with that Pepe had fulfilled his duty of remembrance. As if it were no longer necessary to keep the memory of the other Gisela alive.

"The past was never something he talked about. I don't know why. I didn't ask and my father never told me anything." Not anything about Belgium, France and Dachau either. That is the way myths arise. It was only through me that Hermann learnt that Pepe was never in Spain.

It could be that he rejected his stepmother instinctively.

It wasn't that she treated him badly. "Looked at objectively, she made no difference between me and my sister. Gisi's seven years younger than me, so she needed much more attention, at the beginning they had to spend a lot more time looking after her. Despite that, my stepmother did make an effort for me. But the way things are, when another person behaves as if she's your mother…" At first there were problems at school, then he started having troubles with his health. At a *Kinderland* vacation camp in Klosterneuburg he caught a cold, developed pneumonia that turned into pleurisy, and missed half the school year because of the time he had to spend in hospital and the convalescent home. He was close to dying, he said. Until Albert and Leni came roaring along on his motorbike, "I think that gave me back the will to live." And then the holidays in Linz, where he was closer to his mother (when Kleinmünchen Cemetery was closed down, his grandparents had her name engraved on the family gravestone in the urn grove in Urfahr). With Andi and Albert who let him ride with them in the cab of the works locomotive on the VÖEST site. With Peter, with whom he went bathing. With Leni's husband, who was a model for Hermann because of Franz's air of calm, and because, unlike Pepe, he didn't smoke like a chimney.

Pepe and Magda were unhappy with the way he kept feeling drawn to Linz, clearly there was some ill feeling between the Taurer family and his father that goes back to what happened to Gisela. Gretl Zahradka says that Tschof claimed they held him responsible for her death; her memory of what he said about the disagreement even suggests the family of his first wife were convinced National Socialists, who had set Hermann against his father. That is nonsense, they were and remained communists, even after Gisela's death. It is however conceivable that in contrast to Pepe they refused to accept the orthodox pro-Soviet Party line. That at least is what is suggested by a tortuous sentence in the biographical sketch according to which people who knew Gisela expressed the opinion after her death that she "sacrificed her life and left her 5-year-old son without a mother as a LITTLE IDEALIST, while the GREAT STALIN sent not only enemies and traitors but also his own Party comrades into exile in Siberia or to the firing squad because of differences opinion." The growing estrangement between Pepe and Gisela's family is also suggested by Hermann's memory of an unannounced visit he made to Füchselstrasse: he rang the bell, he says, his grand-

mother opened the door and recoiled when she saw him—because at first she thought he was his father.

That must have been later, after the Tschofenig family had moved to Vienna. Hermann went to high school there, after which he started an apprenticeship as a fitter with Siemens-Schuckert. His aim was to become independent as quickly as possible, to stand on his own two feet, no longer to have to answer to his parents. Perhaps also to get away from the silence surrounding his mother, which was kept alive by the post-war bureaucracy, as can be seen from Pepe's letter to the Taurers: "At the offices of the Carinthian state government nothing is 'OFFICIALLY' known about Gisela's death. A communication to that effect was sent from the register office in Linz to Klagenfurt. After that I applied to the Carinthian state court to try and initiate the process of having her declared dead. That's not possible either! The fact is, then, that officialdom has not registered the events of 1945." In order for Gisela to be declared dead, it needed the testimonies of Resi and Karl Kastner: "I hereby declare..."

Pepe (or Tschof as they called him in the Party) is uniformly described by his comrades Hans Kalt, Irma Schwager, Josefine Seif and Michael Grabner, in almost

the same words, as reserved, unapproachable, taciturn, distrustful, awkward, very hard on himself and on others. Tall, peculiar Carinthian dialect. It was even a special occasion, Fini Seif says, when he once had a coffee with her and her colleague. Walter Wachs, she says, and Rudi Schober, Irma Schwager adds, felt it almost as a special favor when they were allowed to visit Tschof (many years later, when he'd retired from his Party work) in his weekend cottage up on the Semmering Pass. He'd been embittered, Gretl Zahradka adds, it was said his wife had been accused, completely without justification, of a misdemeanor in the firm where she worked as a bookkeeper.

Embittered or disheartened. Hermann remembers how despondent his father was one election Sunday (it could have been the Sunday of every election at which the Communist Party had put up candidates) when the results were announced on the radio.

Pepe's inability to show him affection did not spoil Hermann's enjoyment of the leisure activities of the Communist youth organizations. He was leader of one of the groups in the Young Guard, then transferred to the Free Austrian Youth. It never occurred to him to deny his political background. Whenever he was asked

for his father's profession he would reply, "Official of the Austrian Communist Party. Member of the Central Committee." He found friends in the area around 2 Starhemberggasse, where the family lived. Like him, most, though not all, were the children of Communists, born in exile or underground, in a country that had been conquered by Germany. Hans West, Franz Kostmann, Bruno Geir. Hermann had already been a 'sergeant' back then, Hans says, explaining his choice of word with the fact that 'Tschofi' lavished the affection he lacked at home on others. He looked after his friends like a mother hen, especially a certain Peter, Peter Honsal, who didn't come from a communist family. The one thing that struck him about Hermann's father was that he never asked how his parents were but only his grandfather who, as a Jew, had escaped to Hungary when the Nazis arrived.

They roamed the streets, slipped past their adversary, the janitor armed with a wooden club, into the Theresian Academy, at that time a Red Army barracks that was in the process of being closed down, where they watched the women soldiers, standing legs apart in their relatively short skirts, shooting at a rag with machine pistols. On another occasion they went to see the sculptor Franz Pixner, who

gave them a hammer and chisel each and a lump of stone: "Make something out of that." Hans produced a head, Hermann the emblem of the Free Austrian Youth.

Or they would go swimming, to the FAY baths on the bank of the old arm of the Danube. Or they would go and visit each other, at the Kostmanns it was always open house, you could turn up at eleven in the evening, be offered a cup of tea and hear the music from the next room where Jenö, the journalist, was busy writing, thinking or doing nothing. Bruno lived a bit farther out, on Mollwaldplatz, where his mother was caretaker, and on the corner was an inn where his father regularly went after work; oddly enough the caretaker's apartment wasn't on the first floor but the top floor, one large single room under the flat roof, on which they once planted a house-leek. Whenever they met in West's home, Hermann never forgot, like Tschof, to ask after his grandfather, knock on his door and say hello. It was only the Tschofenig apartment where they were never allowed in. "Tschofi's mother obviously didn't want it messed up." In Hans' memory they often spent hours standing there, drinking milk and chatting to each other about anything and everything, the Korean war, the girls they fancied,

the mopeds they would eventually have, he out in the corridor, Hermann leaning against the door-frame; as far as could be seen from outside the apartment was pretty neat and tidy. Sometimes Hermann's sister would appear. Hans remembers her as "pretty fresh", she was much too young for him to have paid her much attention.

In 1962 Hermann disappeared from Austria. By that time he had long since left home, lived in a room on the Margarethen Gürtel and was still working for Siemens-Schuckert. During a disagreement with the management his own representative on the works council refused to support him, so he resigned and went to Switzerland with a few workmates. At first he worked as a mechanic with Brown-Boveri, then as a fitter with a firm making construction machinery, constantly moving around. He became acquainted with a young woman, they got married, had a little girl, then a boy, he applied for Swiss citizenship, transferred to his father-in-law's firm, a repair shop for all kinds of vehicles and engines. Family quarrel, divorce; earlier on he'd noticed an advertisement looking for border guards, he applied, was accepted, performed his duties at Kloten airport to the satisfaction of his subordinates, who appreciated his social sense, but

also to that of many asylum seekers, to whom he showed a caring face, not that of a defender of the affluent society. At sixty-four, burnt out, as he says, Hermann retired. Now he spends the summer on the Dalmatian cost, in Croatia, the home of his second wife, who for me combines two contrasting qualities: being lively and radiating calm. She thinks it's right that someone is looking into his mother's history.

This haste to run through Hermann's Swiss years in time-lapse photography. Because they are years of repressed memory, of desperate attempts to free himself from family entanglements, of adapting to very different conditions. "I had to shut myself off. Politically things were completely different in Switzerland. A left-wing outlook hardly existed at all. Conditions were somehow sterile—that's not the right word, but it's something like that." On the other hand, Hermann says, whenever he went back to Austria everything there bothered him. "Everything!" The phony friendliness, the stubborn dissatisfaction, the chronic impatience, I suspect. "Even the sticky rings from the glasses on the inn tables." He has, however, seldom been to Austria. Once the family met for a skiing holiday in the Tyrol, once his father

came to see him in Chur and they managed to have an almost normal conversation, though they had to make an effort. Anything that might have been hurtful was avoided. After he got back, Pepe said to Gretl Zahradka, "I've already got two grandchildren, my son, well yes, now I have a good relationship with him." When he died Hermann wasn't informed. He doesn't know when his stepmother died either. He has been in contact with his sister for a year now. She's single and has no children. He had, he says, been able to give his children a socially responsible attitude. Since they were working seven days a week, their interest in the family history was minimal.

THAT ISN'T THE WHOLE of the story, simply an attempt to narrate it from the beginning to its provisional end, full of gaps because I arrived too late as far as Gisela's relatives in Linz are concerned. I didn't manage to find the children of the Tatschl family either (the boy Hermann used to play with in Möltschach might still be alive) or to discover their relationship with Franz Tatschl who had been imprisoned along with Pepe in Wöllersdorf, set off for Spain from Villach in December 1936 and in the spring of the following year died in the hospital

in Murcia from the wounds he had suffered during the Battle of Jarama; I was unable to persuade either Hermann's aunt in Villach or his sister in Vienna to assist my research with information. Gisela Tschofenig left my letter with a request for a conversation unanswered, because of lack of time and because she didn't want to talk about her parents, as I learnt from Hermann; for the same reason the boxes remain closed to me, the ones that contain her parents' documents, as she once told him, material that might shed light on their biography, perhaps even on that of Hermann's mother, but she said that she still hadn't managed to bring herself to open them and sort through the contents, the very idea brought tears to her eyes, and I ask myself what—how and when—can have got into the Tschofenig family, an unforgivable insult, a fault opening up, a rift beyond repair, the consequence of which is that Gisela never really comes alive, never has a clearly defined profile, is condemned to fall again, anew, once more into the Schörgenhub pit.

Question: what actually happened to her boots and to the guard who appropriated them on the night of the murders, who has ever called that woman to account.

If it wasn't for Hermann with his helpful and trust-

ing attitude. If it wasn't for Margit Kain, who wrote a letter to the Mayor of Linz, and then another because nothing precise came out of city hall, with the urgent request to name a street, school or other public facility after her adopted aunt, until her proposal was accepted in February 2006, so that now we can all set off for Ebelsberg, in the outer suburbs of Linz.

TAKE WIENER STRASSE out of town. At the first lights after the bridge turn right onto Kremsmünster Strasse. Follow this for about 550 yards. After building number 38 turn right. (Be careful crossing the cycleway.) Then to the right again, drive onto the gravel car park. Switch off engine, get out, look around. *Gasthof Sportcasino, Lugmair Family, No Parking. Only for customers. Illegally parked cars will be towed away.* Take the asphalt footpath that goes in a northerly then westerly direction between three-storied houses and garages in pink, sky blue, lemon yellow and russet. *Rental parking places for residents alone.* Beyond the houses the riverside woods, invisible behind the woods a tributary of the Traun. Retrace your steps along the blind alley until just before you reach Kremsmünster Strasse.

Raise your eyes and read, tearless, what is on the sign under the street name. *Gisela Tschofenig (1917–1945), opponent of the Nazi regime.* ▪

NOTES

The Klagsbrunn Family
Was written in 2013.
With thanks to Ilse Pollack, who translated Marta Klagsbrunn's poem (pp. 73–75) from the Portuguese. The book of photographs: *Kurt Klagsbrunn: Photographer in the Land of the Future*, ed. Ursula Seeber and Barbara Weidle, was published by Weidle Verlag, Bonn, 2013.

The Photographer of Auschwitz
First appeared in the *Spectrum* section of *Die Presse,* Vienna, 5. 1. 2007.
Wilhelm Brasse died on October 23, 2012 in Żywiec.

Tschofenig: The Name Behind the Street
First appeared in the anthology *Linz Randgeschichten*, ed. Alfred Pittertschatscher, Pictus Verlag, Vienna, 2009.

TRANSLATOR'S BIOGRAPHY

MIKE MITCHELL has been active as a translator for over thirty years. He is the recipient of the Schlegel-Tieck Prize for translations of German works published in Britain, has won the British Comparative Literature Association translation competition twice for works from German along with a commendation for a translation from French, and has been shortlisted for numerous other awards. In 2012 the Austrian Ministry of Education, Art and Culture awarded him a lifetime achievement award as a translator of literary works. He lives in Scotland.